IMAGES
*of Aviation*

VIRGINIA AVIATION

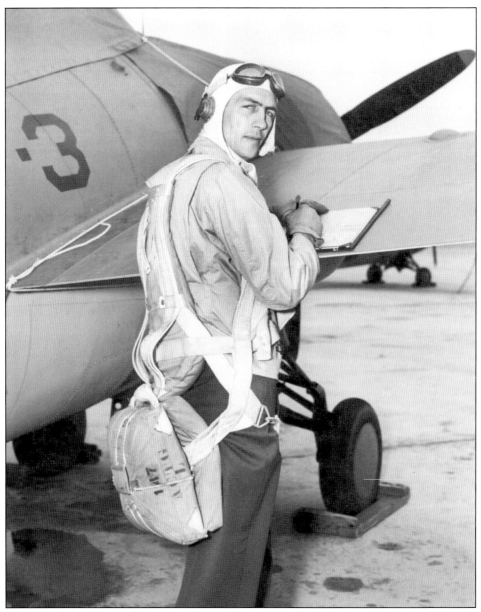

A naval aviator surveys a Grumman F4F Wildcat at Naval Air Station Norfolk in May 1942. Norfolk played a prominent role in World War II as not only a staging ground for Army Air Forces and Navy aircraft and airmen deploying overseas, but also as an active front line in the Battle of the Atlantic. In just 25 years, Norfolk and Hampton Roads had become national centers of aeronautical innovation. (National Archives and Records Administration.)

**On the Cover:** In May 1938, winners of the National Airmail Week essay contest gather at Washington-Hoover Airport in Arlington to pose with an Eastern Airlines Douglas DC-3 captain. Airmail was arguably the greatest single factor in shaping the growth of American commercial aviation before World War II. Virginia benefitted from sitting astride important north-south and east-west airmail routes. (Library of Congress.)

# IMAGES
## of Aviation
# VIRGINIA AVIATION

Roger Connor

ARCADIA
PUBLISHING

Copyright © 2014 by Smithsonian Institution
ISBN 978-1-4671-2245-0

Published by Arcadia Publishing
Charleston, South Carolina

Printed in the United States of America

Library of Congress Control Number: 2014935709

For all general information, please contact Arcadia Publishing:
Telephone 843-853-2070
Fax 843-853-0044
E-mail sales@arcadiapublishing.com
For customer service and orders:
Toll-Free 1-888-313-2665

Visit us on the Internet at www.arcadiapublishing.com

*To my loving wife, Nancy, and daughter, Rebecca, without whose support and dedication this book would not be possible.*

# Contents

| | | |
|---|---|---|
| Acknowledgments | | 6 |
| Introduction | | 7 |
| 1. | The Birth of Military Aviation | 9 |
| 2. | Coming of Age in the Great War | 15 |
| 3. | Feast and Famine in the Interwar Years | 25 |
| 4. | On the Front Lines in World War II | 51 |
| 5. | The Cold War and the Jet Age | 65 |
| 6. | Aerospace Innovation with the NACA and NASA | 73 |
| 7. | Famous Fliers in the Commonwealth | 91 |
| 8. | General Aviation and the Private Pilot | 99 |
| 9. | Commerce on the Airways | 109 |

# Acknowledgments

Books like this exist because of the dedicated individuals at libraries and archives. I give special thanks to several of my colleagues at the National Air and Space Museum (NASM). Tom Paone of the Aeronautics Department kindly assisted me with scanning and copy editing at critical moments. My volunteer, Bob Greene, scrounged Army images. Jessamyn Lloyd of the Archives Department patiently processed and scanned my many photograph requests from the museum's holdings, while Brian Nicklas, Elizabeth Borja, and Melissa Keiser facilitated my research, and Trish Graboske expertly managed the contracting process.

The Library of Congress (LC) deserves recognition for its outstanding work in digitizing its collections and making them accessible, particularly the remarkable Harris & Ewing photographs featured here. The National Archives and Records Administration (NARA) Still Pictures Division is an essential stop for anyone working in military topics, and my time there was a highlight of the project. My enduring gratitude goes to Holly Reed and her staff for the support they have provided through the years. The National Aeronautics and Space Administration (NASA) has wonderful, if somewhat haphazard, online collections that were critical to this project.

An example of getting it right at the local level may be seen with the Norfolk Public Library (NPL), which is now making many period newspaper photographs readily available. Troy Valos provided outstanding service in guiding me through its collections. The Virginia Aviation Historical Society (VAHS) also kindly opened its archives to me. This in turn led me to the venerable Dementi Studios (DS) of Richmond and Dave Miller, who assisted me with obtaining rights and permissions.

Lastly, I would like to recognize the unheralded government and studio photographers responsible for the images that make this book. No narrative history or memoir can document the realities of life many decades ago with the same rich textures as photography. Like the other forms of documentation, photography can be selective and biased, but with a keen eye and open mind, it is an incredibly valuable window to the past. Without the work of the photographers, our understanding of the past would be vastly poorer for it.

# INTRODUCTION

This is the story of a state and its people undergoing one of the most remarkable technological transformations in recorded history. The 100 years between 1861 and 1961 were witness to amazing achievements that ranged from the deployment of balloons in the Civil War to the advent of manned spaceflight. They represent profound revolutions in transportation, communication, and warfare—and Virginia had a ringside seat.

North Carolina lays claim to the tagline "First in Flight," while Ohio does the same with "Birthplace of Aviation"—both for their mutual association with the Wright brothers. Likewise, California has long been the heart of the American aerospace industry, and most other states can make significant claims to shaping the nation's aeronautical heritage. However, no state can claim a richer and more diverse aerospace history than Virginia. From the first balloon flight in the commonwealth in 1801 (near Williamsburg) to satellites launched from Wallops Island, the state has witnessed an astounding number of transformative milestones in civil and military aviation. However, like much of Virginia's history, the military component of the commonwealth's aeronautical legacy merits special distinction relative to other states.

Geographically, there are many reasons for Virginia's aeronautical prominence. The sheltered waters and ocean access of Hampton Roads have made Norfolk and the Tidewater region a cornerstone of national defense for the East Coast. The Army's Langley Field and the Navy's Naval Air Station Norfolk quickly assumed responsibility for defending the Mid-Atlantic region in the middle decades of the 20th century, rendering the grand coastal fortifications at Fort Monroe obsolete. Northern Virginia provided demonstration and landing fields for Washington, DC, while the spacious grounds of nearby Quantico served as a laboratory for the exotic new aerial technologies of the Marine Corps.

The Civil War marked the first American experience with aeronautics in warfare—one that occurred almost entirely within the confines of the commonwealth. Union balloonist Thaddeus S.C. Lowe's demonstrations captured the imagination of President Lincoln, leading to the establishment of a small balloon corps, as well as prompting a competing Confederate balloon program. However, the realities of operations in the Peninsula Campaign did not decisively demonstrate the military value of aerial observation to the degree that Lowe might have liked, and he disbanded the Balloon Corps in 1863, while the Confederate balloon was captured in 1862.

American military interest in aeronautics did not reemerge in a substantive way until the first decade of the 20th century, when the Army Signal Corps began evaluating a series of new technologies for observation, including balloons, Thomas Scott Baldwin's airship, and the Wright brothers' airplane. The Signal Corps' demonstration ground for these new technologies was Fort Myer in Arlington. The Wright brothers' demonstrations of 1908–1909 were successful in convincing the military of the airplane's potential, but they also showcased the risks, as Lt. Thomas Selfridge became the first casualty of powered heavier-than-air flight in 1908.

Glenn Curtiss, the Wright's chief competitor, also found Virginia to be an exemplary proving ground. With Thomas Scott Baldwin, he established a factory and one of the nation's first flight schools in Hampton Roads—the Atlantic Coast Aeronautical Station. As America entered into

World War I, the Aviation Section, Signal Corps (forerunner of today's Air Force) discovered an ideal test site at the location of several old plantations near Hampton. The National Advisory Committee of Aeronautics (NACA, the forerunner of NASA) piggybacked on the construction to establish one of its principal aeronautical laboratories. Across the waters of Hampton Roads, the Navy began aircraft operations at a new site, known as Naval Air Station Hampton Roads (soon to become Naval Air Station Norfolk).

Though American participation in World War I was brief, the aeronautical facilities of the Tidewater had an outsized impact on the region and, more broadly, on aeronautics. Many of the aerospace innovations of the last century may be connected in some way to the highly significant aerodynamic research undertaken there. Most American combat aircraft through the World War II era were validated in part by testing at Langley, as were many civil and commercial aircraft. The space age also had its dawn at Langley and on Wallops Island, where the early space capsules underwent aerodynamic and atmospheric testing and Americans prepared to land on the Moon.

One of the most significant aeronautical events of the early postwar years occurred at Langley Field in 1921 when Brig. Gen. William Mitchell attempted to persuade his superiors, and the country at large, that the bomber had made the battleship obsolete and that only airpower could be decisive in future wars. His aircraft bombed a fleet of captured German and obsolete American warships anchored in the Virginia Capes off the mouth of the Chesapeake. Though the experiment was more like shooting the proverbial fish in a barrel, Mitchell's experiments provoked a debate in the American military that ultimately had profound implications for the way the nation fights its wars. During the interwar years, the Marine Corps also established its own center of innovation at Quantico, where it could develop new aerial tactics. This paid off significantly in the Cold War, when the concept of using helicopters for air mobility was fleshed out with the aircraft of squadron HMX-1 that would eventually become synonymous with transporting the president by helicopter.

The attempts by Germany's U-boat force to sever the seagoing lifeline between the United Kingdom and the United States during the Battle of the Atlantic in 1942–1943 placed Langley Field and Naval Air Station Norfolk on the front lines of combat operations. Norfolk also served as the birthplace of America's carrier force, as home to the first shipboard flight of an airplane in 1910 by Eugene Ely, as well as the construction of the USS *Langley* (CV-1), the Navy's first carrier.

The Cold War brought new threats and new opportunities. Jet aircraft required larger facilities, ultimately culminating in Dulles Airport, which substantially shaped the built landscape of Northern Virginia. More ominous infrastructure appeared in the commonwealth as well, with nuclear-tipped antiaircraft missile batteries proliferating in Northern Virginia to defend the nation's capital against Soviet bomber formations.

Virginia was also an ideal way station on the emerging aerial highways connecting north and south on the eastern seaboard. Washington and Richmond quickly grew as aviation terminals, first in response to the increasing demand for airmail and then in support of passenger service. The same aeronautical design revolutions that allowed Charles Lindbergh to cross the Atlantic in 1927 also fed the rapid growth of civil aviation in the commonwealth during the late 1920s. General aviation (personal flying) also expanded rapidly in this period. Small sod runways proliferated across the state. As airplanes became more complex, some of these airports added paved runways and expanded, while others succumbed to suburban construction.

Commercial aviation posed special challenges by requiring paved runways of ever-greater lengths. This was especially true in Northern Virginia, which was home to a series of three airports that have served as the capital's air link. The tension between infrastructure requirements of higher-performance airliners and the need for ease of access can best be seen between 1941 and 1961 as Washington struggled with the limitations of Washington-Hoover and then Washington National, ultimately resulting in the construction of the spacious, but remote, Dulles Airport.

# *One*
# THE BIRTH OF MILITARY AVIATION

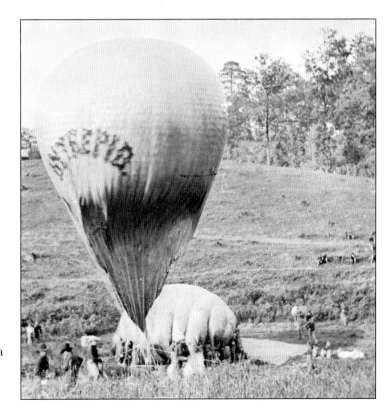

During the Battle of Fair Oaks (May 31–June 1, 1862), Thaddeus S.C. Lowe made several tethered ascents above Union lines at Gaines' Farm (near Gaines' Mill), to observe Confederate movements northeast of Richmond. This Mathew Brady photograph depicts Lowe's *Intrepid* during inflation with hydrogen gas. While Lowe's balloon flights marked a milestone as the first American military aeronautical program, the Peninsula Campaign remained its only significant use. (NASM.)

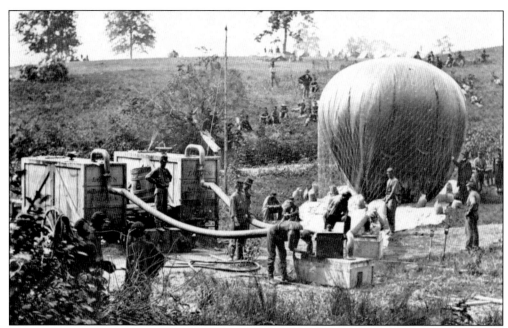

Lowe's most significant innovations were in the infrastructure and process of balloon inflation. The gas-generation wagons are visible to the left of the *Intrepid*. They created hydrogen gas by the filtering of dilute sulfuric acid through iron filings. Lowe himself appears to the right of the *Intrepid*, inspecting the inflation process. The balloon was spherical when fully inflated. (NASM.)

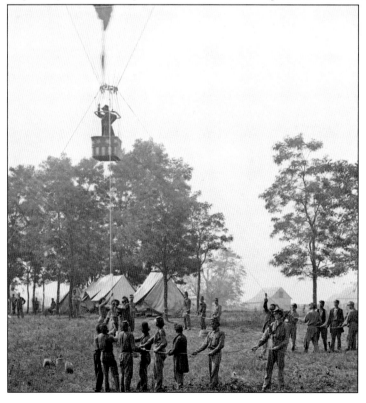

Lowe ascends in the *Intrepid* during the Battle of Fair Oaks. The Balloon Corps' biggest flaw was that commanders did not know what to do with the improved perspective offered by the aerial observer. The tethered balloon ultimately proved its worth in adjusting indirect artillery fire, but only decades after the Civil War, though artillery spotting by balloon did occur in the Western theater. (NASM.)

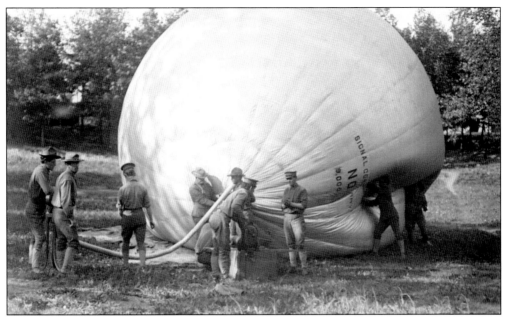

The Army Signal Corps revived its interest in ballooning in the early 1890s and successfully deployed balloons in Cuba during the Spanish-American War. This photograph depicts training at Fort Myer around 1908. These hydrogen balloons were much smaller and simpler than those used a decade later on the Western Front. While very effective for directing indirect artillery fire, they were incredibly labor-intensive to operate. (NASM.)

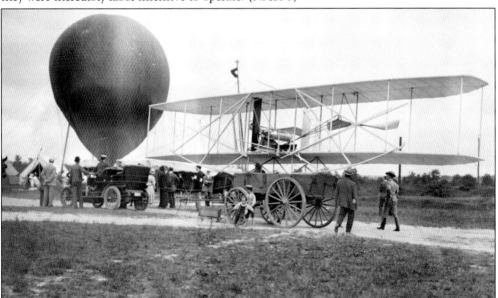

The heavier-than-air flying machine and wireless communication promised a far greater capability and flexibility for Signal Corps observation. This requirement resulted in an advertisement for bids answered by the Wright brothers. This photograph depicts the Wright military airplane on September 3, 1908, at Fort Myer, after assembly and preparations for flight were completed. The balloon is storing hydrogen for the Signal Corps' other major aircraft program, the Baldwin SC-1 airship. (NASM.)

A young Carl Claudy Jr., the son of the photographer, watches the Wright airplane at Fort Myer in September 1908. A boy of his age who grew to be 70 years old would have lived to see the Wrights' first flight as well as the moon landing, along with the enormous cultural changes of the technological 20th century. For many, seeing an aircraft in flight for the first time was a personally transformative experience. (NASM.)

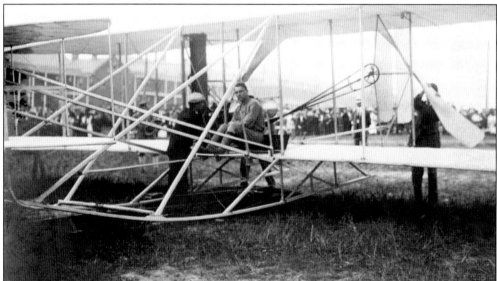

Orville Wright began demonstrating the Wright airplane for the Army at Fort Myer on September 3, 1908. On September 9, he flew Lt. Frank Lahm as a passenger—a first for the US military. Here, on September 17, Orville Wright instructs Lt. Thomas Selfridge before takeoff. With 2,000 spectators on hand, Wright felt something go wrong on the fourth circuit of the parade grounds while at an altitude of 100 feet. (LC.)

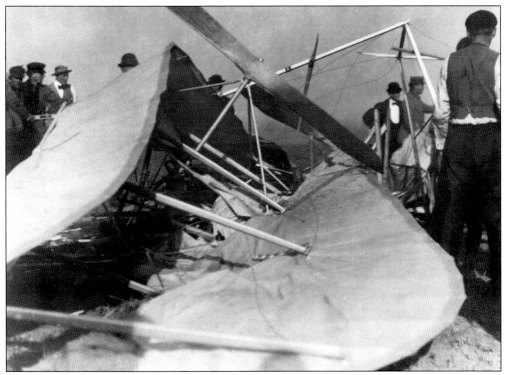

One of the airplane's two wooden propellers had split and caused the failure of a structural support wire, which sent the aircraft into a dive. Neither Wright nor Selfridge was wearing a restraint or helmet, and the airplane collapsed around them on impact. A crowd rushed over to free them. Wright was seriously injured with a broken hip, but Selfridge was in far worse condition. (NASM.)

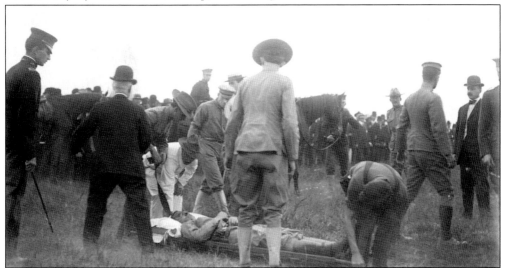

Selfridge suffered severe head trauma. He is seen here after being pulled from the wreckage. Despite surgery to relieve swelling on the brain, he died three hours after the impact, becoming the first person to perish in a powered heavier-than-air flying machine—Otto Lilienthal and others had previously died in gliding accidents and attempts. Fortunately, the tragedy did not completely overshadow the overall impression of the Wrights' accomplishments. (NASM.)

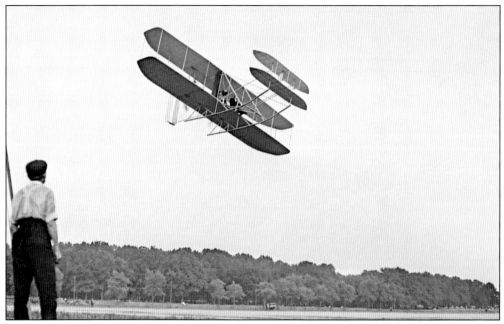

On June 3, 1909, the Wrights returned to Fort Myer with a new airplane of similar configuration but with strengthened components. The performance trials went smoothly, including a 10-mile round-trip to Shooter's Hill in Alexandria, leading to the acceptance and purchase of the Army's first airplane, now known as the Wright Military Flyer. It is currently on display at the Smithsonian Institution National Air and Space Museum. (LC.)

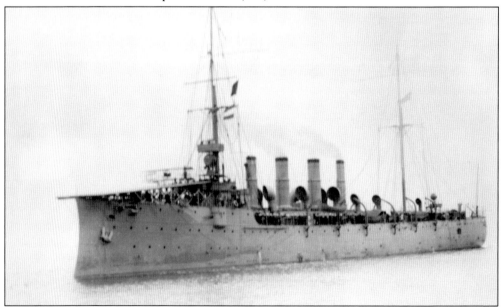

The Navy was also interested in the airplane. Here, the light cruiser USS *Birmingham* (CL-2) steams into position near Old Point Comfort at the mouth of the James River on November 14, 1910. Curtiss demonstration pilot Eugene Ely then made the first shipboard takeoff from an 83-foot-long temporary deck in a Curtiss Pusher; Ely barely cleared the water and landed three miles away on a Norfolk beach after becoming disoriented. (NARA.)

# Two

# COMING OF AGE IN THE GREAT WAR

In an unusual antecedent to the air traffic control tower, a fireman stands on crash watch in an observation post above a hangar at the Aviation Experiment Station (Langley Field) in Hampton. This duty is a testament to the hazards of testing early military aircraft. Langley aviators were testing a wide range of unfamiliar equipment, often with limited experience themselves, so crashes were not unusual. (NARA.)

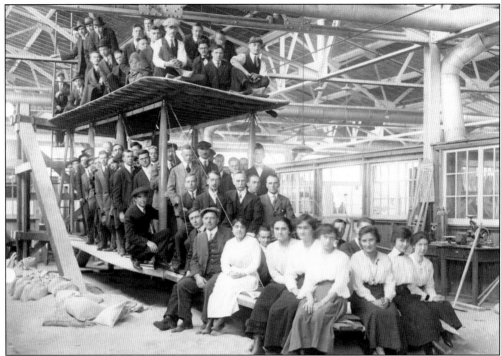

While military investment fueled rapid technological development in European aeronautics, American innovation continued at a peacetime pace until 1917. In 1915, the Curtiss Aeroplane Company established a facility in Newport News, called the Atlantic Coast Aeronautical Station, to train pilots and teach aircraft maintenance and assembly. Here, company personnel demonstrate the load-carrying capacity of an H-12 flying boat wing on October 28, 1916. (NARA.)

Atlantic Coast Aeronautical Station students wait out the weather at the company offices. In addition to instruction, the facilities offered charter airline service as far away as New York City. The operation attracted many who would later become prominent aviators. These included airpower architect William "Billy" Mitchell, polar flyer Bert Acosta, and aircraft manufacturer Eddie Stinson. Most importantly, the facility served as a nucleus for Hampton Roads' wartime aeronautical infrastructure. (NASM.)

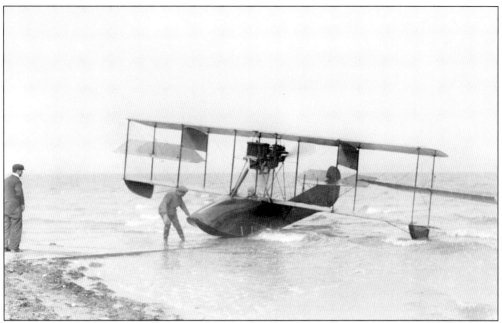

A Curtiss F-Boat is launching or recovering from a flight at the Atlantic Coast Aeronautical Station, sometime in 1916. The F-Boat was an excellent trainer for the new generation of flying boats that would be so important to the forthcoming American war effort. While too light for landings in coastal surf, the type was at home in the calmer waters of the Chesapeake. (NPL.)

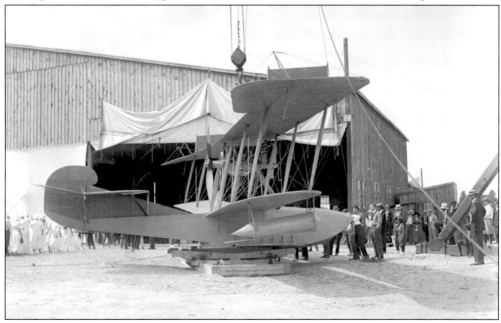

Here, an Atlantic Coast Aeronautical Station MF-Boat undergoes final assembly in front of the facility's main hangar in 1916. Such activities were popular spectator sports in Newport News. Residents, not without reason, felt their region was now on the cutting edge of an important new technology. The rapid wartime growth of Langley Field and Naval Air Station Hampton Roads further supported this perception. (NPL.)

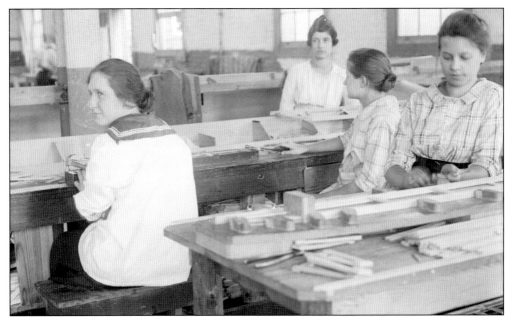

"Rosie the Riveter" was already a well-known concept when World War II started. Here, Virginia women assemble aircraft during World War I. When the United States entered the war in 1917, demand for training aircraft exploded, and Curtiss could not meet demand. In Alexandria, the Briggs Airplane Company (later Alexandria Aircraft) received a Navy contract to build Curtiss MF-boats. The armistice ended the business. (LC.)

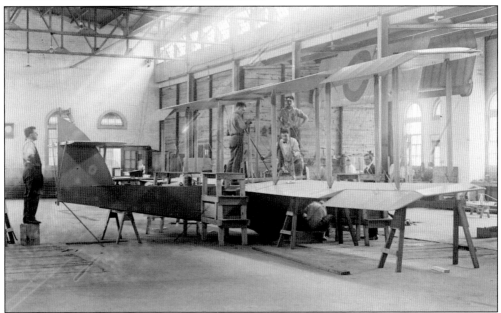

A.W. Briggs had tried to ensure his Alexandria-based company's survival by developing its own designs, including this F-19, which he intended to supplant the MF-Boat in training operations. Unfortunately for Briggs, his design did not live up to the Navy's expectations, and it did not enter production. For all of its aeronautical achievements, aircraft manufacturing has not been one of the commonwealth's strengths. (LC.)

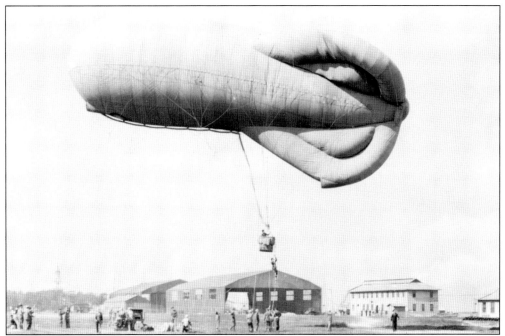

The tethered kite balloon was a far more capable tool than Lowe's balloons of 55 years earlier. They were part of a complex system of devastating indirect artillery fire. However, hydrogen-filled kite balloons, like this one at Naval Air Station Hampton Roads, were also vulnerable to attack and difficult to handle. Each one required scores of personnel and a number of vehicles to operate, as well as extensive antiaircraft protection. (LC.)

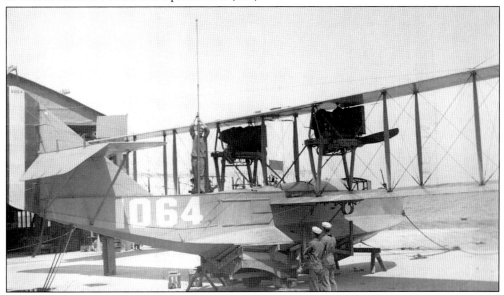

World War I defined modern warfare. Beyond aeronautics, a broad range of technologies emerged simultaneously, including wireless communication. Aerial observation was one thing, but relaying critical information in a timely way was another. Here, a Curtiss H-16 at Naval Air Station Hampton Roads is fitted with a wireless transmitter in June 1918. Such equipment was essential to combating the U-boat threat. (NARA.)

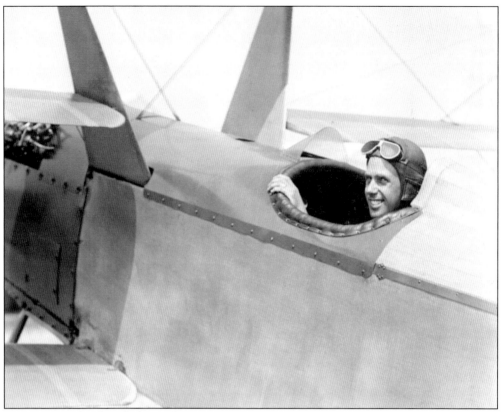

An aviator, only identified as "Johnson," prepares to take off in a Curtiss S-3 Triplane Scout in July 1917 at Langley Field in Hampton. Established by Congress the previous year as the Aviation Experiment Station, the site was to facilitate military aeronautics by coordinating research between the Army, Navy, and National Advisory Committee for Aeronautics. (NARA.)

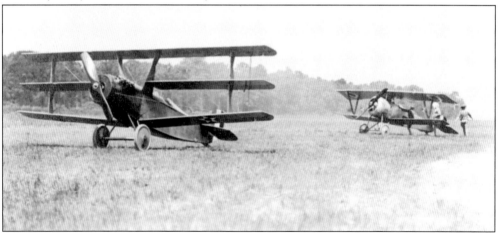

A Curtiss S-3 stands ready in the foreground at Langley Field while a pilot climbs into a Nieuport 17 for an evaluation flight. The Signal Corps ordered the S-3 before America entered World War I as the nation's first true fighter plane. By the time they were ready for production, it was abundantly apparent that European models were far superior, and the Signal Corps only acquired four. (NARA.)

A ground crewman prepares to "hand prop" a Standard JR-1B at Langley Field in 1918. Only a handful of these advanced trainers had been acquired by the Aviation Section, Signal Corps. The aircraft is supporting the photographic school, which taught pilots and observers the basics of photograph reconnaissance. The airplane's greatest contribution in World War I was its use in detecting enemy movements before they gained momentum. (NARA.)

A pilot, perhaps somewhat questioningly, looks at the experimental Olmstead propeller that has been installed on his Curtiss JN-4B "Jenny" at Langley Field in 1917. The plane is also sporting experimental Ackerman wheels with spring steel spokes to cushion landings. Charles Olmstead's propellers created a stir in the late teens and early 1920s with his claims of high efficiencies. Unfortunately, the type's advantages were offset by a range of weaknesses. (LC.)

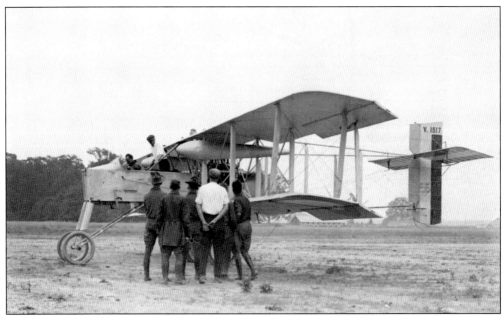

In June 1917, Langley Field began playing host to an extensive array of Allied aircraft, including this French Voisin 8, to evaluate them for American production. The stagnation of the American aviation industry over the previous two years made such steps necessary. By this time, the Voisin was already a hopelessly obsolete observation aircraft and night bomber. It is on display in the Smithsonian Institution National Air and Space Museum. (NARA.)

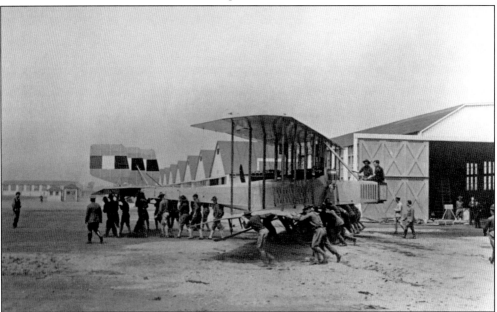

The Caproni Ca.46, or as it was known in wartime by the US Army, the Caproni 600 HP, was an Italian bomber under evaluation at Langley Field for license-built production in America. A Fisher Body Works–produced Liberty engine-powered example is seen here on Langley's flight line in September 1918. The smaller Caproni 450 HP (Ca.36) was the primary bomber used by the American Expeditionary Force on the Italian front. (NARA.)

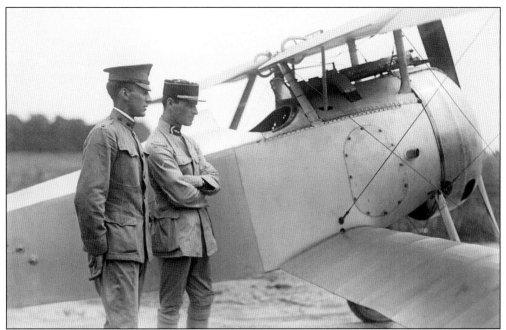

The primary wartime activity of Langley Field was to determine which European aircraft were suitable for license-built production in the United States, given the complete inadequacy of existing American combat aircraft. Here, Captain Bartolf of the Signal Corps consults with Lt. E. LeMaitre of the Aéronautique Militaire on the merits of the French Nieuport 17. (LC.)

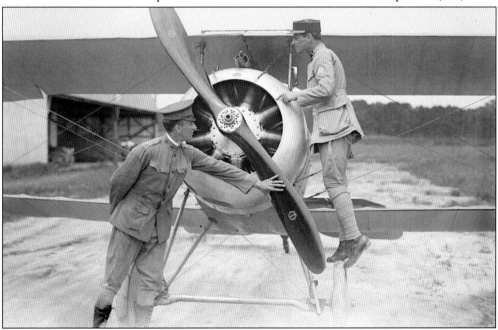

Bartolf and LeMaitre continue their exploration of the aircraft. While a good fighter when introduced, by this time, the Nieuport 17 was already becoming obsolete. The Army did not select it for domestic production, but the American Expeditionary Force acquired some as pursuit trainers in France. (LC.)

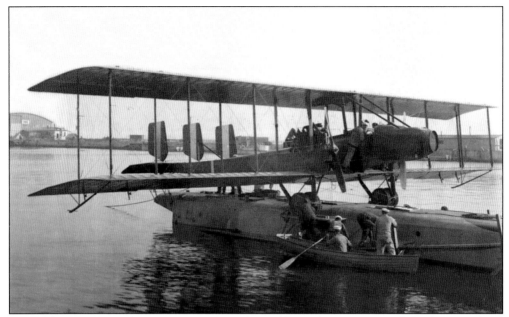

One of the more unusual wartime tests of Langley Field was the Mustin Sea Sled. This specialized 50-knot speedboat brought aircraft to flying speed on the water. The idea expanded on British experience with towed barges for anti-zeppelin patrols in the North Sea. Here, the Caproni Ca.46 is prepared for testing on the Sea Sled shortly after the armistice. The Sea Sled was not accepted for service. (NARA.)

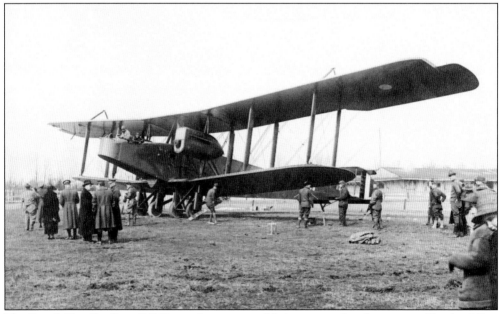

The British Handley-Page O/400 was the most capable long-range bomber operated by the Allies in World War I and was America's first heavy bomber. The Army Air Service placed the Liberty engine–powered model into domestic production with the Standard Aircraft Corporation, but none were ready for deployment before the armistice. This example is undergoing inspection at the Richmond Aviation Depot in 1918. (NASM.)

# Three
# FEAST AND FAMINE IN THE INTERWAR YEARS

Brig. Gen. William "Billy" Mitchell was the contentious and ambitious deputy commander of the Army Air Service after World War I whose strident faith in airpower helped shape the emerging doctrine of strategic bombing in the interwar years. During the early 1920s, Mitchell sought to demonstrate the destructive power of multiengine bombers, particularly against the battleships that he saw as white elephants in an air age. (LC.)

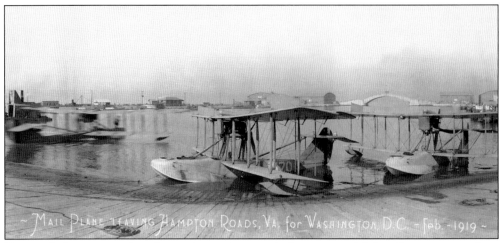

Navy mail planes operated regular courier services even before commercial airmail was commonplace. Here, Curtiss HS-1Ls are moored at the flying boat ramp, Naval Air Station Hampton Roads, while a HS-2L taxis out of the harbor to take off for Naval Air Station Anacostia. Soon after, the Navy's flying boats became too large to pass under the bridge and it had to be demolished. (NASM.)

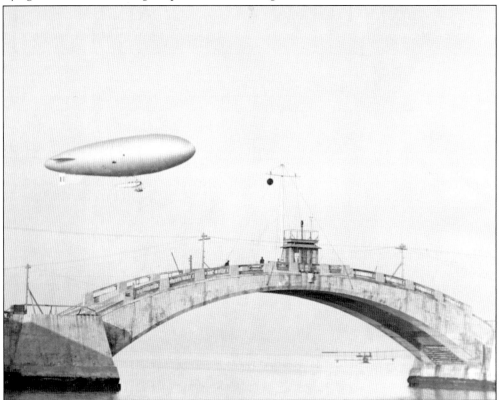

A Navy nonrigid C-class airship maneuvers back to Naval Air Station Hampton Roads, passing by a Curtiss Model H flying boat. Airships remained an interwar mainstay of coastal patrol even though they were slow and labor-intensive. British airships had proven remarkably effective against U-boats in the North Sea during World War I by providing a persistent observation platform. Both the US Navy and Army operated them for coastal patrols. (NARA.)

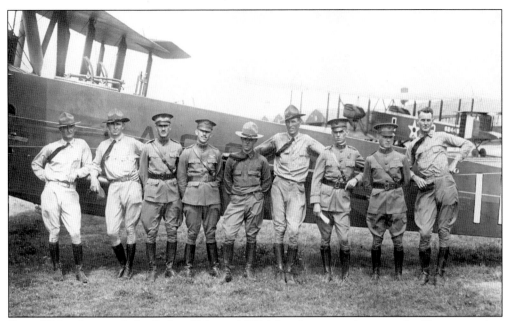

Capt. Walter Lawson led a flight of Martin NBS-1 bombers over the war-prize German cruiser *Frankfurt* and sank it during the 1921 Mitchell bombing trials. The Langley Field officers pictured here are presumably Lawson and his aircraft commanders. Though the tests were conducted jointly with the Navy, Mitchell used them to argue the superiority of airpower over traditional naval forces, which caused a rift between the military services. (NARA.)

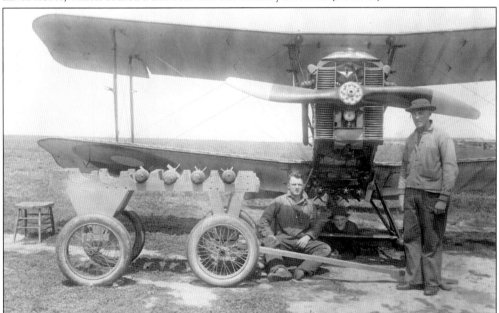

The 1921 Mitchell bombing trials forced the Army Air Service to come to terms with handling a wide range of ordnance in a way it had not done in World War I. Here, a Langley Field ground crew utilizes an improvised cart to transport 25-pound bombs for mounting on an Eberhart SE-5. The 25-pound bombs could not pierce armored plate, but they could disable antiaircraft guns on target vessels. (NARA.)

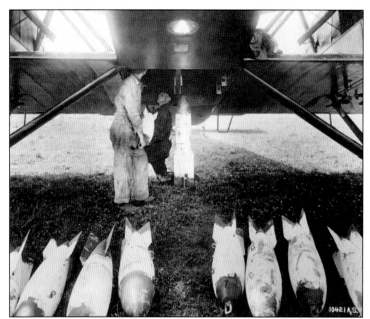

The inadequacy of existing bomb-handling equipment may be seen here as Langley Field armorers load 100-pound bombs into the belly of a Martin NBS-1 by hand during the preparation for the bombing trials in June 1921. These bombs were not sufficient to do real harm to armored warships; 600-pound bombs were necessary to sink the German cruiser *Frankfurt*, and the battleship *Ostfriesland* required 2,000-pound bombs. (NARA.)

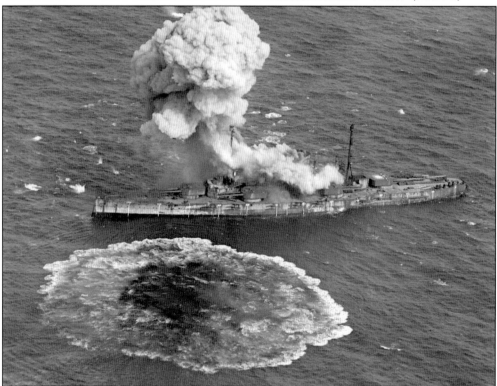

The 100-pound bombs dropped by Martin NBS-1s strike the German battleship *Ostfriesland* on July 21, 1921, with little measurable effect. Later, 2,000-pound bombs breached its hull. While sinking battleships was never as easy as Mitchell argued, a new age in aerial warfare was clearly dawning. Navy leaders were also beginning to realize that its carriers were going to become more significant than mere platforms for scout planes. (NARA.)

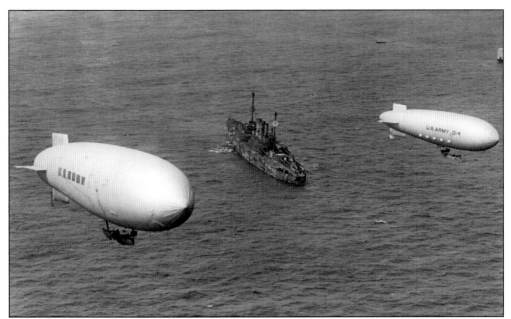

On July 21, 1921, the Army Air Service's C-2 and D-5 airships circle the German battleship *Ostfriesland* shortly before Langley-based Martin NBS-1 bombers would sink it with 2,000-pound bombs. An inspection party is leaving the ship on the port side after it surveyed the damage caused by 600-pound bombs earlier in the morning. The sinking earned Mitchell significant public acclaim, much to the Navy's dismay. (NARA.)

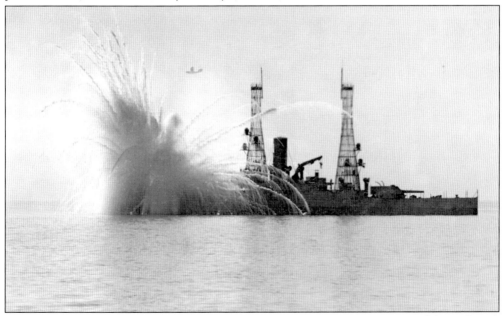

A phosphorous bomb explodes over the aft deck of the retired battleship USS *Alabama* (BB-8) in September 1921 off Tangier Island in the Chesapeake Bay. The phosphorus bombs were a training aid to help the Martin NBS-1 crews refine their tactics. The ship sank in shallow water on September 27. Navy critics charged that Mitchell's trials were biased as he attacked static targets, not maneuvering vessels. (NASM.)

While Mitchell's bombing trials off the Virginia Capes advanced the cause of strategic bombing, the Navy was advancing its own aeronautical revolution with the construction of its first aircraft carrier, the USS *Langley* (CV-1), seen here undergoing conversion from its previous status as the collier *Jupiter* (AC-3) at the Norfolk Navy Yard in August 1921. (NARA.)

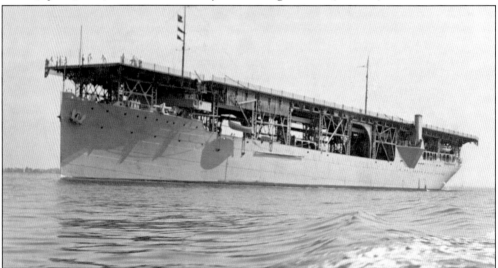

Here, *Langley* sits at rest in Hampton Roads not long after its commissioning in March 1922. The *Langley* allowed the Navy to understand the nuances of carrier operations during the 1920s while the more capable *Lexington* (CV-2) and *Saratoga* (CV-3) were under construction. It underwent conversion to a seaplane tender in 1936 and was sunk in 1942 by Japanese dive-bombers. (NARA.)

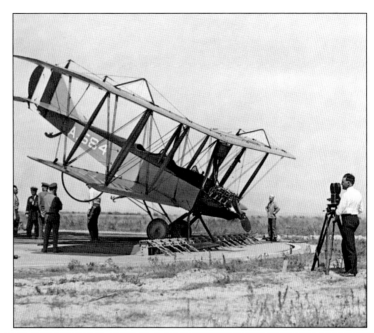

An Aeromarine 39B is stopped by a barrier after missing its arresting wire with the hook on its belly during 1921 trials in preparation for the launch of the USS *Langley*. Lieutenant Commander Chevalier made the first landing aboard the *Langley* in a 39B on October 26, 1922, marking an important new phase of naval warfare for the US Navy. (NARA.)

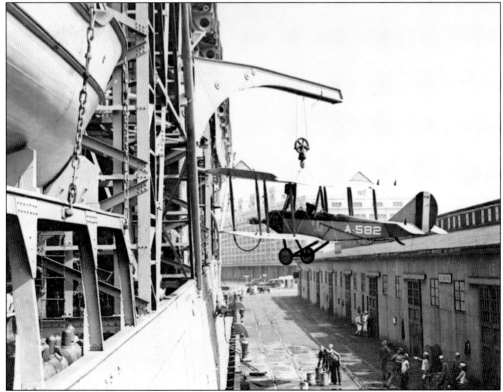

*Langley* seamen hoist an Aeromarine 39B aboard for the first shipboard handling trials. By late 1924, *Langley* was performing regularly in fleet exercises. *Langley* was neither fast enough to keep pace with battle fleets nor able to carry enough aircraft to be combat effective. However, it was an excellent platform with which to work out the kinks of naval aviation. (NARA.)

Personnel pose with the LWF (Lowe, Willard, and Fowler) Model H Owl at Langley Field in 1921. The Army Air Service acquired the one-off example, which had been built as an express mail freighter, to evaluate as a potential replacement for its fleets of Martin bombers. The type did not outperform the Martins and proved to be accident-prone. (NASM.)

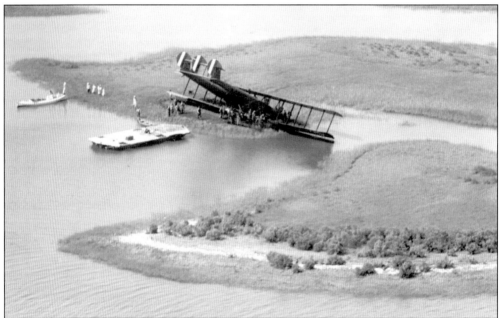

On June 3, 1921, the Owl's crew made a lucky escape from a forced landing after an engine failure over the Back River marshes near Jamestown. The aircraft suffered significant damage, but the company rebuilt it and had it flying again by 1923, by which time the Air Service had lost interest. In 1927, an Orteig Prize competitor, the Keystone Pathfinder *American Legion*, crashed near the same spot, killing its two crewmen. (NASM.)

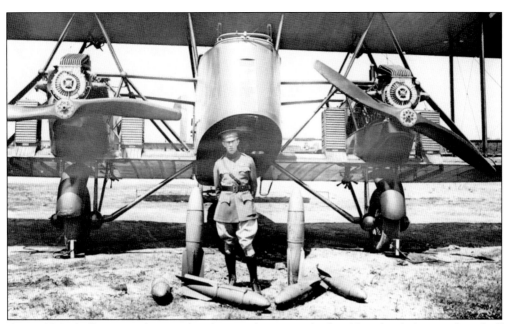

General Mitchell's request for more bombing trials against obsolete Navy battleships anchored off of Cape Hatteras was approved by the US Department of War in the summer of 1923. Mitchell realized he needed larger ordnance to be successful and not these 100-pound bombs, but the Martin NBS-1 could not lift 2,000-pound bombs to the 10,000 feet required for the test. The solution was the addition of the innovative Moss turbo-superchargers, pictured here. Major Reynolds, commander of the 2nd Bomb Group, is pictured here. (NASM.)

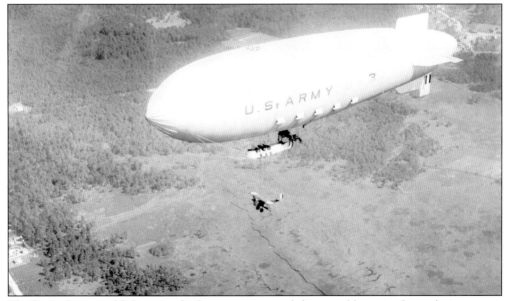

The limited range of fighters made their use in coast defense problematic. One solution was to have an airship act as a mother ship. Langley Field participated in tests involving the D-3 airship and a Verville-Sperry M-1 Messenger. Here, the M-1 achieves the first docking between an airplane and an airship on September 18, 1923. The Navy put the technique to use on its rigid airships in the 1930s. (NASM.)

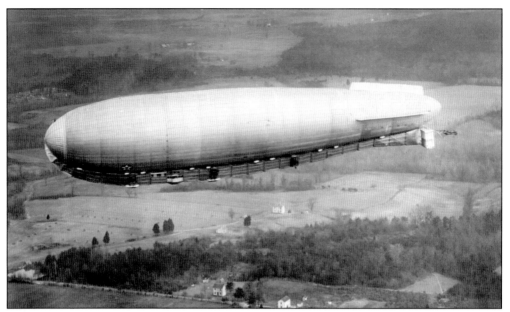

The semirigid *Roma* was the nation's first large airship. The Army purchased it from Italy in 1921 for use in coastal patrols, mapping, and as a freighter for redeploying aircraft squadrons. Assembly occurred at Langley Field in the fall of 1921. It first flew on November 15 and is seen here on a flight to Bolling Field, located in Washington, DC, on December 17 for presentation to the Army leadership. (NARA.)

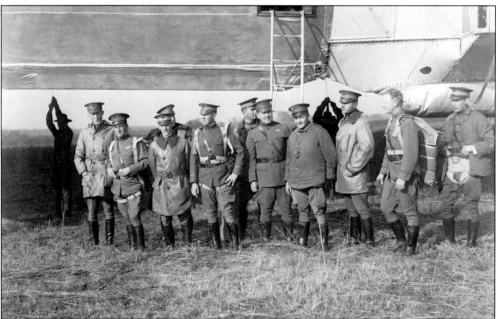

The officers of the *Roma* pose before its maiden flight. American military planners perceived the nation falling behind the European powers in the use of large airships, which they viewed as the most effective means of projecting airpower over long distances at sea. The *Roma* was plagued with troubles at the outset and its engines required replacement shortly after operations began. (NARA.)

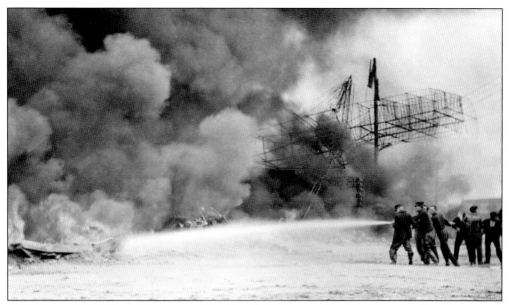

On February 21, 1922, the *Roma* passed by Naval Air Station Norfolk when it suffered structural failure, descending on to power lines, where the hydrogen gasbags ruptured and ignited. The inferno killed 34 of the 45 personnel on board. This was the same number of fatalities that occurred on board the *Hindenburg* 16 years later (though one ground crewman was also killed in that accident). (NARA.)

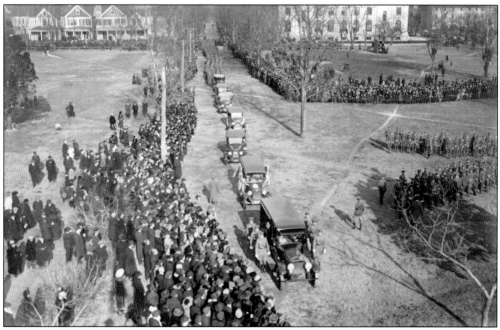

The funeral procession for the *Roma* fatalities wound its way through the streets of Newport News on February 24, 1922. Most of the survivors were guests or observers and nearly all killed were regular crewmen. The disaster soured the Army Air Service on large airships and led to the push in the United States to move from cheap, but hazardous, hydrogen to expensive, but inert, helium. (NARA.)

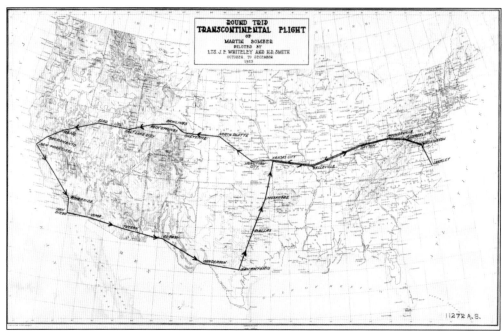

Army Air Service commanders realized that to compete for scarce peacetime dollars they needed to hold the public's attention. Langley Field was often at the center of such demonstrations, including a transcontinental tour by one of Langley's 20th Bombardment Squadron MB-2s in 1923. Unfortunately, between bad weather and lack of spare parts, the flight stretched out into three months. These shortcomings helped spur congressional support for air operations. (NARA.)

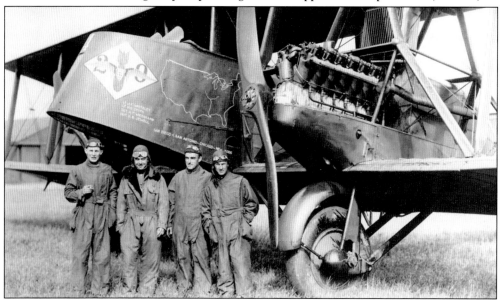

The transcontinental MB-2 crew consists of Lieutenants Whiteley and Smith on the left and ground crewmen Wiedekamp and Jewell on the right. A practical goal of the flight was to assess the suitability of the MB-2 for military and civilian airmail service. Not surprisingly, this did not become a new mission for the Martin bomber, which soon disappeared out of service in favor of the new Keystone bombers. (NASM.)

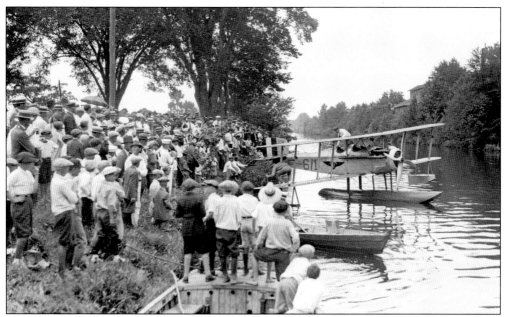

On July 17, 1925, Langley Field and Naval Air Station Norfolk helped the public celebrate the completion of one of the Norfolk region's first significant hard surface highway projects—the George Washington Highway, which ran from Wallaceton to the North Carolina border. Here, a Vought VE-7SF from the battleship USS *Arkansas* (BB-33) attracts a crowd. Unlike later catapult-launched scout planes, this one was simply lowered over the side for a water takeoff. (NPL.)

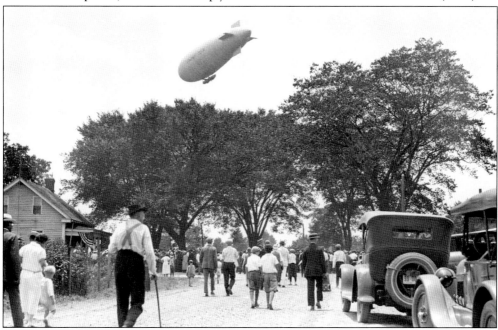

Langley Field also supported the opening of the George Washington Highway by sending the TC-4 airship. In the aftermath of the *Roma* disaster, the US military shifted from hydrogen to helium. This was safer, but more costly and cumbersome. Earlier in 1925, TC-4 served as a platform for solar eclipse observations near Washington. (NPL.)

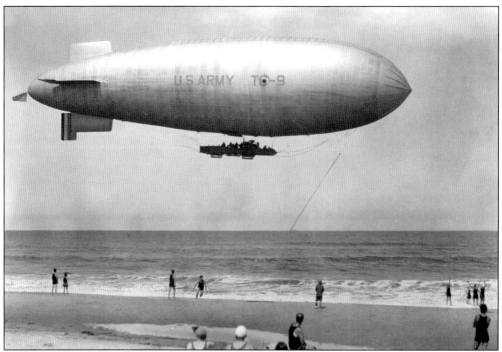

Army airships were a staple in the skies around Virginia Beach in the 1920s. Here, TC-9 gives beachgoers a thrill. The Langley-based airships ranged the length of the Chesapeake and along the Atlantic coast to Delaware and south to Hatteras. The airships' airborne endurance made them an ideal coastal patrol platform, provided they kept a good lookout for severe weather that they would be hard-pressed to outrun. (NPL.)

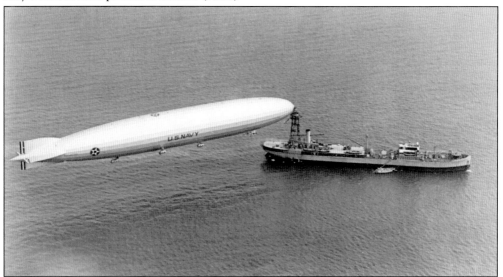

The Navy's rigid airships eclipsed the military blimps in grandeur and performance. The USS *Shenandoah* (ZR-1) sits moored to its tender, USS *Patoka* (AO-9), in July 1925 at Hampton Roads. Inspired by the wartime German height-climbing zeppelins, it was the pride of the Navy's Bureau of Aeronautics. Tragically, on September 3, it was caught in a storm over Ohio and broke apart, killing 14 of the 43 on board. (NARA.)

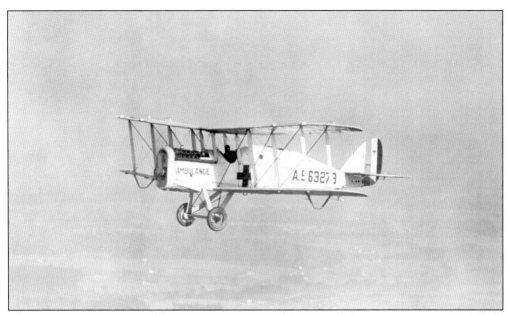

The Liberty engine–powered DH-4 was a mainstay of Army and Marine air operations in World War I. It served well into the 1920s, including as an ambulance for use at Army Air Service fields like this Langley-based example. A hinged "turtle deck" had room for two stacked stretchers. The flying ambulance saved time, but the dark, confined space must have been terrifying for the injured. (NARA.)

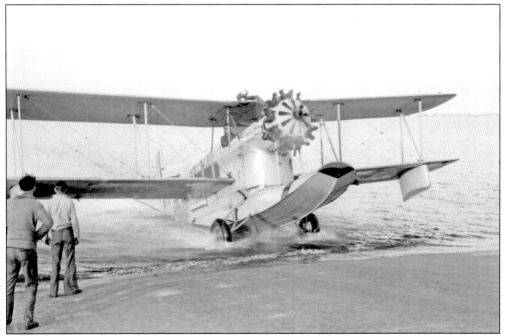

The Navy also acquired ambulance planes. This Loening XHL-1 operated from Naval Air Station Norfolk starting in the late 1920s. It is seen here on November 24, 1928, bringing in Mrs. V.J. Williams with appendicitis from remote Hatteras Island. Today, the helicopter medevac is taken for granted, but to have benefitted from a similar capability in the 1920s is remarkable. (NPL.)

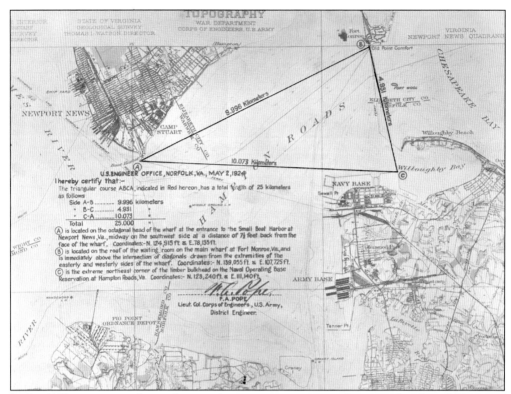

In the 1920s, aeronautical record setting became synonymous with national pride and Hampton Roads served as the site of a number of record runs. In November 1924, lieutenants Victor Bertrandias and G.C. MacDonald flew 40 laps on this 25-kilometer closed course in a Loening S-1 Air Yacht to establish a new seaplane record of 102.642 miles per hour. The military services took special pride in dominating these record categories. (NARA.)

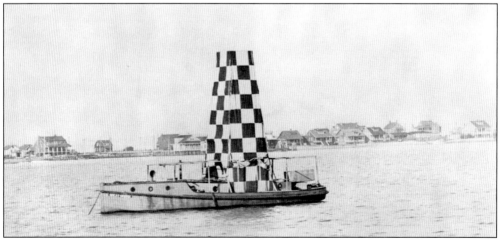

The premier showcase for aeronautical technology in the 1920s was the Schneider Trophy Race. The leading aeronautical powers put forth their best military crews and specialized racers. Rarely run outside of Europe, the 1926 race occurred in Hampton Roads, shining an international spotlight on the commonwealth. The seven-lap 50-kilometer course started at this pylon in Willoughby Bay near Naval Air Station Norfolk. (NARA.)

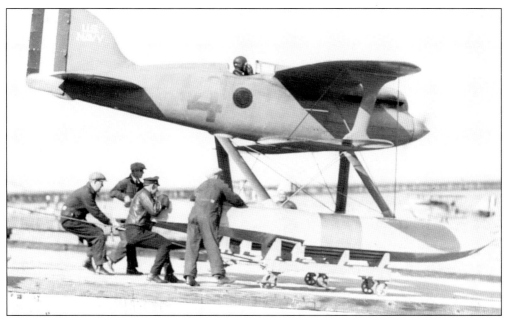

The 1926 Schneider Trophy Race featured an Italy versus United States competition after the United Kingdom dropped out due to a lack of suitable engines for its racers. Each country fielded teams of three fast, but marginally controllable, aircraft for the November 13 race. Here, Lt. George Cuddihy prepares to launch in the Curtiss R3C-4. He ran out of gas and had to land before completing the final lap. (NARA.)

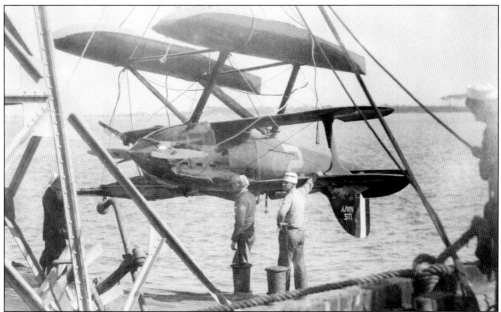

On November 11, 1926, Lt. William "Red" Tomlinson became a last-minute substitution on the Navy's Schneider team and made his first practice flight in the Curtiss R3C-3, which had a reputation as a difficult aircraft. On his first landing, he hit hard and cartwheeled, coming to rest inverted in the water. Tomlinson managed to extricate himself, miraculously uninjured. He raced a slow, conventional Curtiss F6C-3 Hawk seaplane fighter in the actual race. (NARA.)

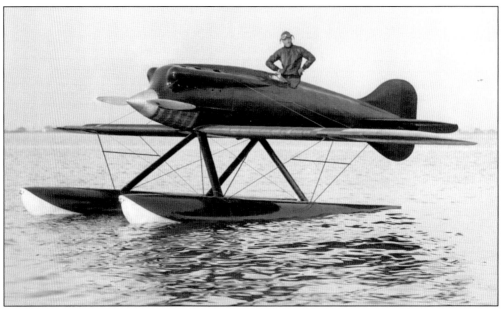

The Italian team featured three sleek Macchi M.39 racers. Here, Maj. Mario de Bernardi strikes a confident pose during practice on November 8, 1926. Winning the Schneider Trophy required designing for race parameters rather than building a general high-performance aircraft. By 1926, the United States' enthusiasm for expending resources on this type of niche application had begun to dwindle, and later competitions became British-Italian races. (NARA.)

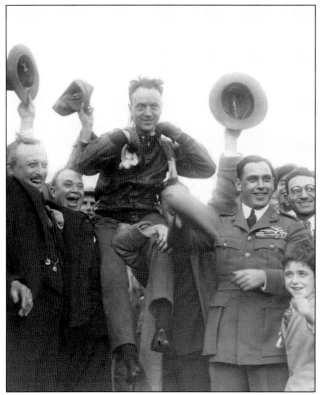

Maggiore de Bernardi won the race with a speed of 393.688 kilometers per hour. Navy lieutenant Frank Schilt placed second in the Curtiss R3C-2. The Italian team had no trouble celebrating as it had smuggled Chianti into the United States in the floats of its M.39s to skirt Prohibition-era customs control. This was the Italians' last Schneider triumph as the outstanding British Supermarine racers dominated the final three Schneider competitions. (NASM.)

The emphasis on speed and streamlined design for air racers did not translate immediately into combat aircraft of the 1920s. By 1930, Air Corps bombing formations still relied on lumbering biplanes, like this Keystone LB-7 of Langley's 2nd Bomb Group. Depression-era budgets exacerbated the slow pace of change, and the 2nd had to hang on to its Keystones until 1935, when the vastly superior Martin B-10 replaced them. (NARA.)

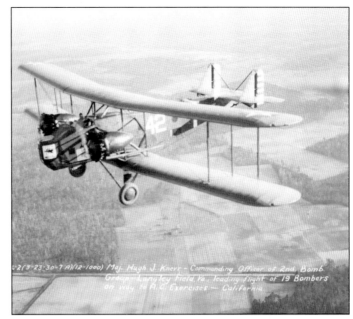

These 20th Bombardment Squadron Keystone LB-7 crews are participating in war games. They deployed from Langley Field to the nearby Richard E. Byrd Flying Field in Richmond, sometime in 1934. The nature of bombardment squadron deployments, whether real or exercise, began to change significantly in the late 1930s, as aircraft like the B-17 could no longer operate from smaller fields and exercises began to lose their "campout" flavor. (DS.)

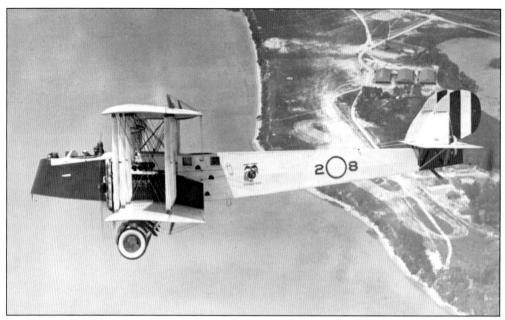

A Martin MBT of Marine Corps Fighting Plane Squadron Two (VF-2) orbits over Brown Field at Marine Corps Air Station Quantico in 1926. The Marines operated six Martin MBTs in the 1920s. Originally intended for bombing and torpedo attack missions, they became transports and squadron utility aircraft. The MBTs supported parachute training and demonstrations in which the parachutist would deploy the parachute while standing on the wing. (Author's collection.)

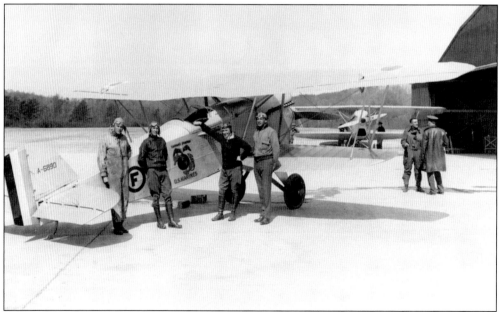

Marine Corps aviators fought well in World War I flying DH-4s on attack missions. The year 1925 brought something new when air-to-air combat became a central mission in the new Marine Fighting Plane Squadrons. They began in spring 1926 with the arrival at Quantico of six Boeing FB-1s, two of which are seen here at Brown Field on April 27. Within a year, some of these pilots and ground crew would be deploying to Nicaragua to fight Sandino rebels. (Author's collection.)

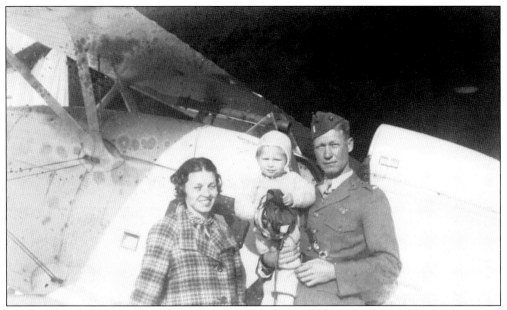

Lt. Frank Dailey of squadron VF-9M poses beside his wife, Flora, and son, John, in front of a Boeing F4B-4 at Brown Field, Quantico in 1935. Dailey was a respected senior squadron pilot who had fought the Sandino rebels in Nicaragua. John grew up to be assistant commandant of the Marine Corps, deputy administrator of NASA, and director of the Smithsonian Institution National Air and Space Museum. (NASM.)

Marine Corps Air Station Quantico underwent significant changes in the 1930s. Brown Field No. 1 was closed in favor of new Turner Field (still in operation). Brown Field No. 2, seen here, remained in operation for some time. This 1934 photograph is showing off the new name for what was previously known as Aircraft Squadrons, East Coast Expeditionary Force. (NARA.)

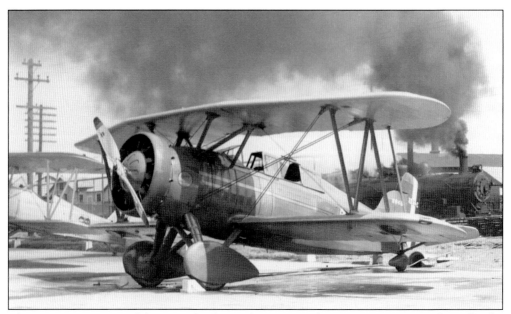

The assistant secretary of the Navy for Air in the Hoover administration was David Ingalls, the US Navy's only World War I ace. Ingalls worked to triple the naval air fleet through the onset of the Depression. He especially liked to fly himself on inspection tours in colorfully marked aircraft like this Curtiss XO2C-2 (a type famed for combating King Kong in the 1933 film) parked at Marine Corps Air Station Quantico's Brown Field. (NARA.)

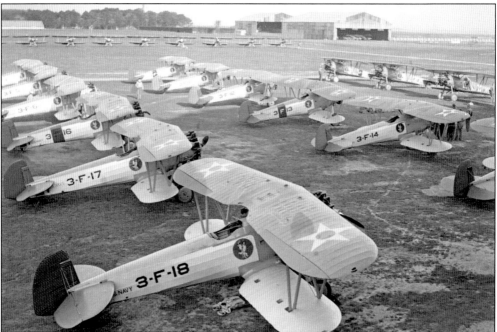

Boeing F3B-1 fighters from the carrier USS *Lexington*'s squadron VF-3B are pictured on the line at Naval Air Station Norfolk on May 5, 1930. The squadron was overnighting with others from the *Lexington* and *Saratoga*. This type was short-lived in service as the more-nimble Boeing F4B soon replaced it in carrier operations. (NPL.)

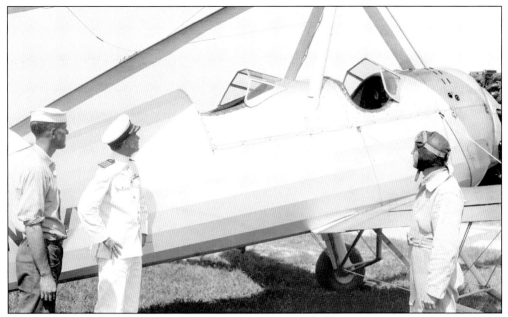

The autogiro was the first successful rotary-wing aircraft. The Navy, in spite of not having a clear mission for the type, bowed to congressional pressure in 1931 and acquired three Pitcairn XOP-1s for evaluation. Here, pilot Lt. Alfred Pride is perhaps explaining the nuances of the freewheeling rotor to a fellow officer. The advantage of the autogiro was that it could make near vertical landings and was stall-proof. (NPL.)

On September 23, 1931, Lieutenant Pride flew an XOP-1 from the USS *Langley* under way in Hampton Roads. This was the first shipboard takeoff and landing of a rotary-wing aircraft. As the autogiro's rotor was unpowered, it could not hover. After testing, the Navy still could not conceive of a relevant mission. In 1932, the Marine Corps employed one of the XOP-1s on its Nicaraguan intervention with moderate success in noncombat roles. (NARA.)

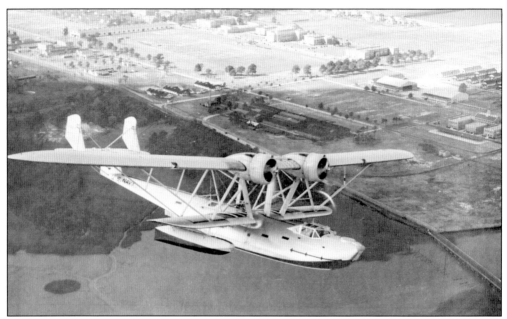

A Consolidated P2Y-2 of Squadron VP-10 flies over Naval Operating Base Norfolk on October 23, 1935. When the P2Y entered service in 1933, it represented a significant new capability in Navy patrol flying boats. It had sufficient range to fly nonstop from Norfolk to Coco Solo in the Panama Canal Zone. These aircraft remained in operational squadron service until the eve of the Pearl Harbor attack. (NARA.)

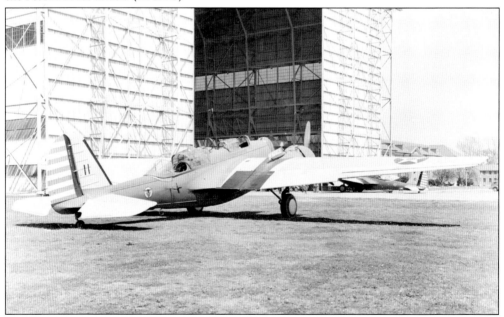

A Martin B-10B sits by the Langley airship hangar in 1939. In the mid-1930s, when it entered service, the B-10 was a groundbreaking aircraft, with all-metal monoplane construction, retractable gear, and a nose turret. It was a short-lived, but useful, stepping-stone between biplane Keystone bombers and the B-17. By 1939, it was already obsolete and this example was a target tug for training the antiaircraft batteries at Fort Monroe. (NARA.)

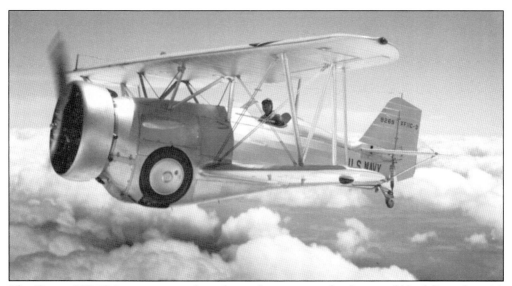

The Curtiss XF11C-3 presents a striking figure flying over a cloud-covered Norfolk on June 14, 1933. This was a one-off retractable gear and up-engined version of the F11C-2 (later BFC-2), which was itself a variant of the Army's Curtiss Hawk. The F11Cs were a footnote fighter, serving primarily in squadron VF-1B aboard the USS *Lexington*. Retractable gear became a much more important innovation when the Navy switched to monoplane fighters. (NARA.)

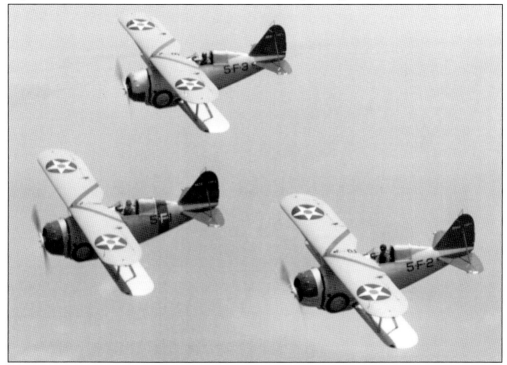

A flight of three Grumman F2F-1s operates near Norfolk on July 17, 1938. Concerns over high landing speeds delayed the entry of monoplanes into the carrier force. In the interim, biplane fighters like these bore the brunt of fleet air operations. Fortunately, the Grumman F4F Wildcat was arming the fleet before this generation of aircraft was called to fight the Pacific War. (NARA.)

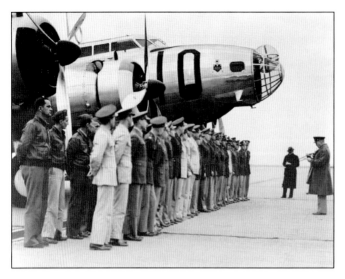

In February 1938, Col. Robert Olds led a flight of six Boeing Y1B-17s from Langley to Buenos Aires via Miami and Lima, Peru—a 5,225-mile journey. The "Goodwill Flight" was of enormous technical and political significance. It validated the capability of the new Flying Fortress and it sent a "hands-off" message to Germany about interference in South America. Here, Gen. Frank Andrews greets the returning crews upon their arrival at Langley. (NARA.)

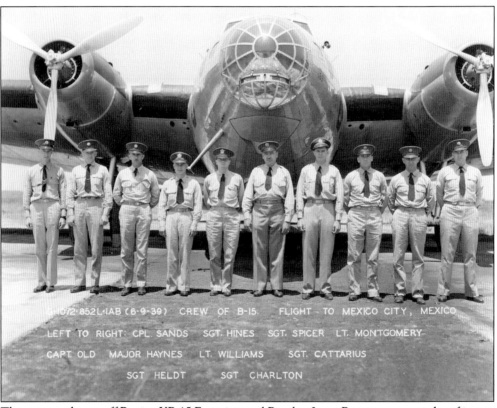

The mammoth one-off Boeing XB-15 Experimental Bomber Long Range was a wonder of its age but too large and complex for production under peacetime budgets. It was nonetheless a useful long-range transport. In 1939, it flew a dramatic disaster relief mission from Langley to Chile. The photograph documents a 1939 flight to Mexico City to return the body of Francisco Sarabia, Mexico's national aviation hero. (NARA.)

# Four
# ON THE FRONT LINES IN WORLD WAR II

An unidentified member of Langley Field's 20th Bombardment Squadron, 2nd Bombardment Group poses for the camera in July 1942. The squadron was still flying the first-generation Y1B-17s, received several years earlier, on antisubmarine patrols off the Virginia Capes. The 2nd would soon receive new B-17s and go on to fly over 400 missions in Europe with the 12th and 15th Air Forces based in North Africa and Italy. (LC.)

During 1941, the Japanese threat kept Langley's contingent of B-17s small. Instead, the base's primary weapon on the eve of World War II was the Douglas B-18A, seen here at Langley in September 1940. While the B-18 never fulfilled its intended battlefield mission, it was an essential defense weapon for the coast during much of the war, especially with the addition of radar and magnetic anomaly detectors to target U-boats. (NARA.)

A 2nd Bombardment Group Y1B-17 prepares for another antisubmarine patrol. The First Sea Search Attack Group soon called Langley home and allowed the 2nd to deploy to Europe as a Heavy Bombardment Squadron. The number of submarines they attacked was small, with one confirmed and one possible kill. However, aircraft patrols were a strong deterrent to U-boat operations in coastal waters. (LC.)

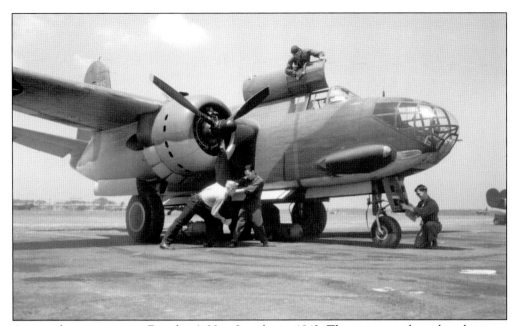

A ground crew services a Douglas A-20 at Langley in 1942. The unit is unclear, though it may be the 304th Bombardment Group on antisubmarine duty. The A-20 was a reliable battlefield interdiction aircraft, but medium-range bombers have long overshadowed it in popular memory. It was also a desirable Lend-Lease aircraft that saw extensive service with Britain, France, and the Soviet Union. (LC.)

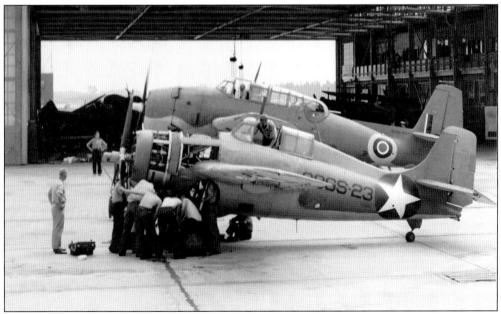

In September 1942, a Lend-Lease Grumman Tarpon (Avenger) sits next to a Grumman F4F Wildcat undergoing maintenance at Naval Air Station Norfolk. Lend-Lease is often overlooked, but its significance is undeniable. These two Grumman products constituted one of every five British Fleet Air Arm aircraft in the war. British Tarpon operations ranged from attacking the German battleship *Tirpitz* to bombing the Japanese home islands. (NARA.)

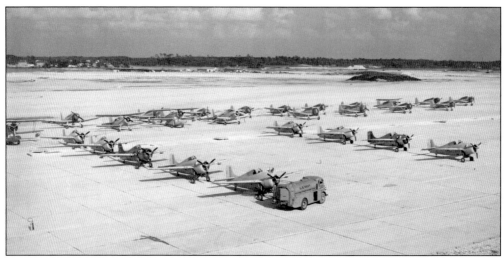

Grumman F4F Wildcat fighters awaiting deployment sit arrayed on the ramp at Naval Air Station Norfolk on February 10, 1942. The base served as an important transit point for Atlantic squadrons. While the Pacific theater rightly claims the lion's share of attention for the critical role of naval aviation, it was also essential in the Atlantic in providing antisubmarine cover and supporting amphibious landings. (NARA.)

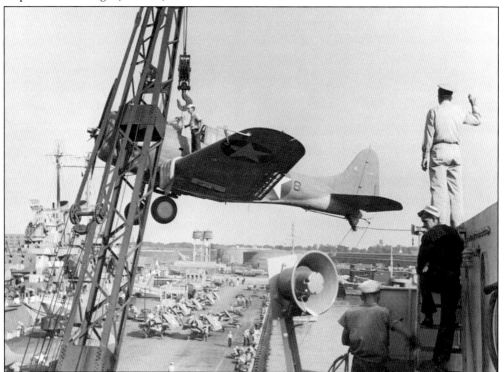

Crews hoist a Douglas SBD Dauntless dive-bomber aboard the escort carrier USS *Santee* (ACV-29) at Naval Operating Base Norfolk for its shakedown cruise in October 1942. On its first voyage, one of the SBDs inadvertently bombed the ship on takeoff, causing moderate damage. *Santee* provided antisubmarine protection for convoys through 1943 and then deployed to the Pacific, where it survived a kamikaze strike and a submarine torpedoing. (NARA.)

Occasionally, Navy carriers launched Army Air Forces aircraft during amphibious operations. This first occurred in Operation Torch during the invasion of North Africa in November 1942. Here, 33rd Fighter Group Curtiss P-40F Warhawks line up for loading aboard the escort carrier USS *Chenango* (ACV-28) at Pier No. 7, Naval Operating Base Norfolk on October 22, 1942. The diminutive *Chenango* carried over 70 P-40s for the operation! (NARA.)

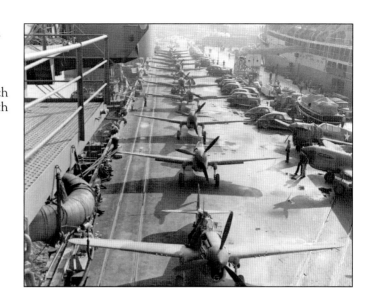

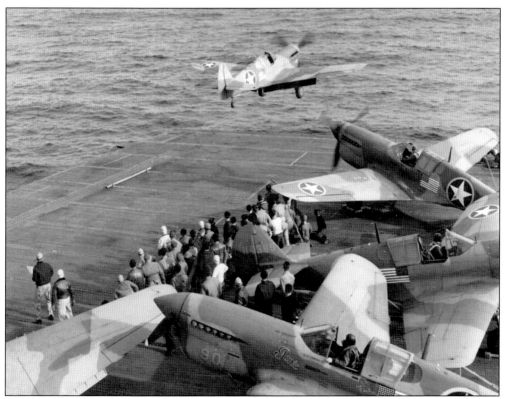

Once the USS *Chenango* approached the Moroccan coast, the P-40s launched using a bridle connected to a hydraulic catapult. On November 8, when the P-40s departed, they were to fly to an airfield recently secured from the Vichy French forces. Unfortunately, the airfield had been shelled by naval gunfire and made the operation hazardous. Larger carriers at the time did not require catapults. (NARA.)

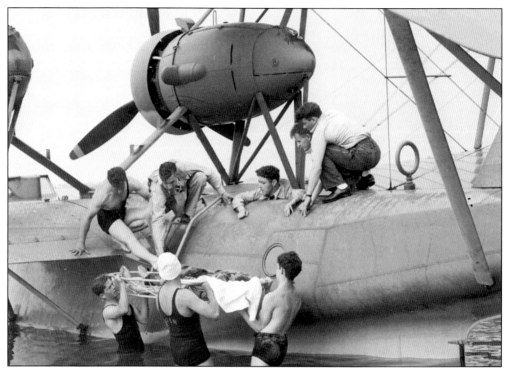

On April 21, 1942, German submarine U-84 torpedoed the freighter SS *Chenango* (no relation to the carrier) 60 miles southeast of Cape Henry. Two of the 32 crewman made it into a boat and survived 12 days adrift before being picked up by this Coast Guard Hall-Aluminum PH-2, seen here with one of the survivors. Unfortunately, one of the two died of his injuries two days after this was taken. (NARA.)

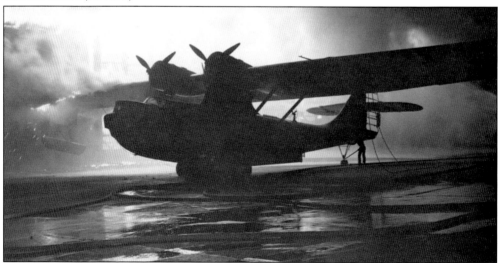

Not all losses were caused by the enemy. Accidents, including this November 13, 1942, hangar fire at Naval Air Station Norfolk that claimed a Consolidated PBY Catalina, were all too common in the high-intensity operational environment of Tidewater military bases. The PBY was a mainstay of Allied maritime patrol, serving throughout the duration of the war and in all theaters. (NARA.)

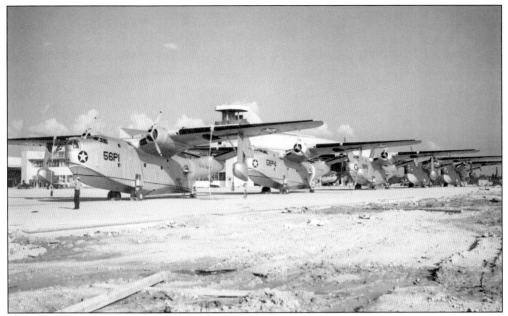

The Martin PBM Mariner represented a superb new long-range antisubmarine patrol capability that entered service on the eve of America's entry into World War II. The critical factor in turning the tide against the U-boat threat was the marriage of radar with long-range patrol aircraft. Combined with Allied code-breaking, these patrol aircraft made surfaced submarines a much easier target along the convoy routes. (NARA.)

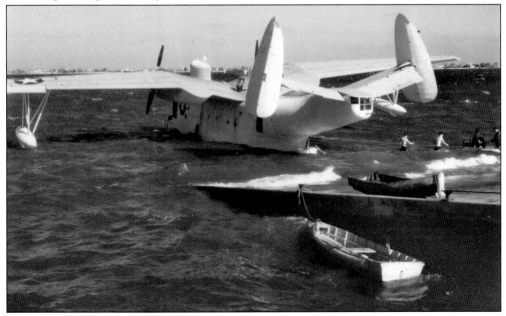

A Martin PBM-3 floats by the seaplane ramp at Naval Air Station Norfolk in December 1943. Launching and recovering seaplanes was an unpleasant and arduous task, especially in cold weather. Before the recovery crew could pull the aircraft from the water, they had to install heavy and cumbersome beaching gear (wheels). The hump behind the cockpit holds the AN/APS-2 search radar, critical to locating submarines. (NARA.)

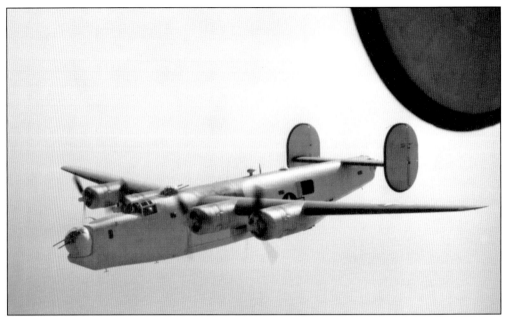

The longest-range and most potent of the Norfolk-based antisubmarine patrol aircraft was the Consolidated PB4Y-1. Its long range permitted the closing of the mid-Atlantic gap in aerial protection for England-bound convoys. This Norfolk-based example, photographed in December 1943, shows off the type's bulbous nose turret that distinguishes it from the Army Air Forces B-24 on which it was based. (NARA.)

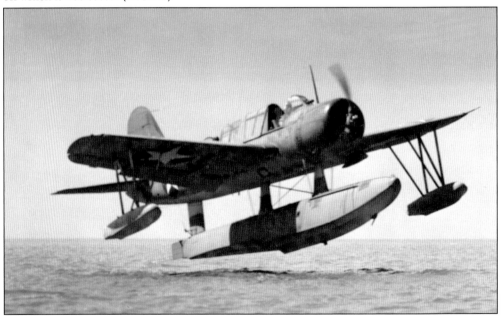

Another maritime patrol mainstay off the Virginia coast was the Vought OS2U Kingfisher, like this one seen returning to Naval Air Station Norfolk in September 1942. The Kingfisher typically served as a catapult-launched scout plane off of cruisers. One of its more successful applications was in the search-and-rescue role, recovering survivors from sunken ships and downed aircraft. (NARA.)

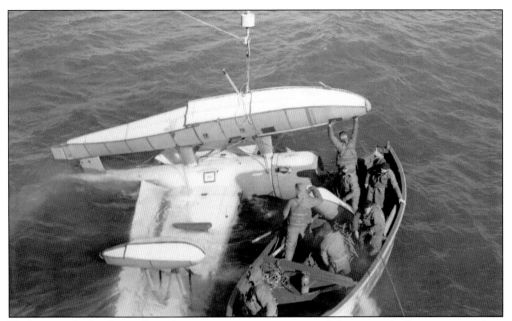

Unfortunately, landing a floatplane in open water was one of the more challenging operations in naval aviation, and the risks were high. Here, one of the four Vought OS2U-3 Kingfishers belonging to the cruiser USS *Quincy* (CA-71) flipped over while attempting a landing in the Chesapeake on December 1, 1944. The three crew members apparently escaped, but exiting the aircraft in such a situation could be challenging. (NARA.)

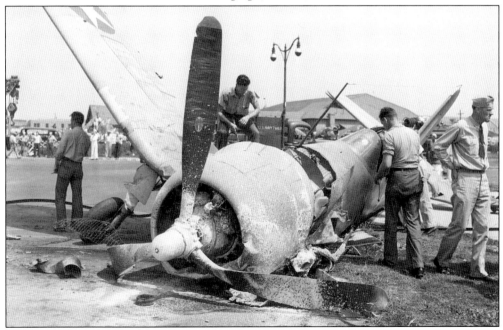

The pilot of this Vought F4U, Allan Marshall, miraculously escaped serious injury after suffering an engine failure on takeoff from Chambers Field at Naval Air Station Norfolk on August 4, 1943, while making a test flight. Marshall put it down on the edge of the flight line, damaging two other aircraft. It then skidded into the main street of Naval Operating Base Norfolk. (NARA.)

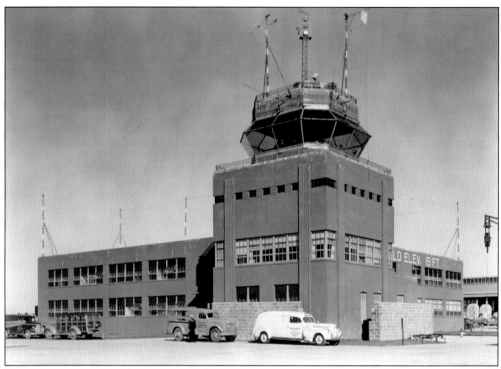

World War II shaped the Tidewater landscape significantly through a massive increase in infrastructure. The operations building and control tower of Naval Air Station Norfolk, seen here in September 1944, represented a shift in air traffic control from simple light-gun signals to radio communications. While certain critical airfields in operational theaters were using approach radars in poor weather, domestic airfields were not. (NARA.)

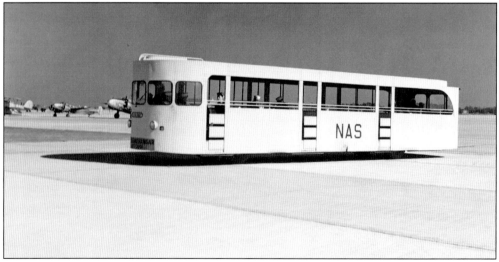

Seen here in November 1941, this 1939 World's Fair bus was one of the more unusual vehicles seen on the flight line at Naval Air Station Norfolk during the World War II years. Several naval air stations benefitted from the repurposing of these futuristically styled buses, helping to solve a desperate demand for support vehicles as wartime production began fielding tens of thousands of new aircraft on an annual basis. (NARA.)

On January 11, 1944, in the mid-Atlantic, Norfolk-based Lt. (JG) Leonard McFord made the first American rocket attack on a U-boat while flying an Eastern Aircraft TBM-1C Avenger from the USS *Guadalcanal* (CVE-60). Though he was credited with a possible sinking, the submarine, U-758, survived the attack. Here, McFord describes the incident to Distinguished Flying Cross recipient Lt. Paul Sorenson, who helped sink U-801 on March 16, 1944, flying an Avenger from the USS *Block Island* (CVE-21). (NARA.)

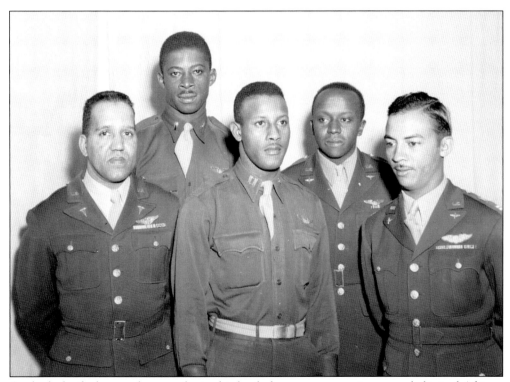

As the lack of relevant photographs in this book demonstrates, racism severely limited African American participation in Virginia aviation from 1861 to 1961. Small numbers of black aircraft owners and pilots resided in Northern Virginia, but broader opportunities did not appear until the cultural upheavals of World War II. Here, Army Air Forces aviators of the Tuskegee Airmen pose as they visit Langley Field, possibly while recruiting, in December 1944. (NPL.)

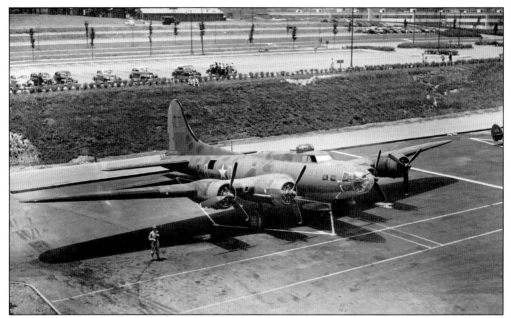

Perhaps the best-known combat aircraft of the European theater was the Boeing B-17F Flying Fortress *Memphis Belle*, seen here at National Airport on June 16, 1943. This 91st Bomb Group aircraft was the first Army Air Forces heavy bomber and crew to complete 25 missions and return to the United States. It is preserved at the National Museum of the United States Air Force in Dayton, Ohio. (NARA.)

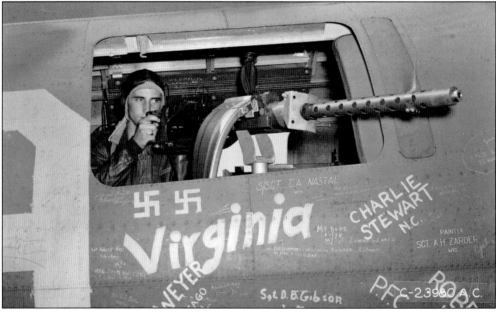

The arrival of *Memphis Belle* at National Airport was the beginning of a media blitz to emphasize the progress of American forces in Europe and to support the war bond drive. Here, waist gunner SSgt. Casimer Nastal of Detroit poses at his station. Visitors were allowed to scrawl their names on the aircraft. *Memphis Belle* had much of the tail and a portion of a wing replaced due to flak damage. (NARA.)

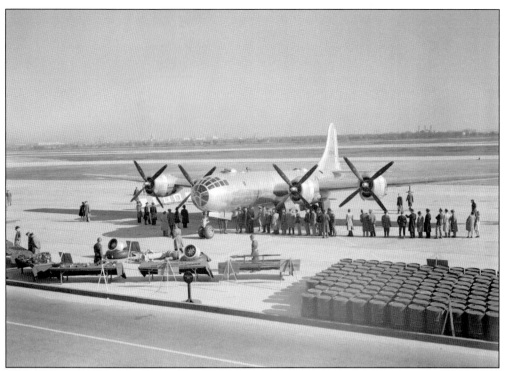

The Boeing B-29 Superfortress was the most sophisticated combat aircraft of World War II. While jet fighters and helicopters represented important advances in specific technologies, the B-29 incorporated an incredibly broad array of new technologies ranging from computer-guided central fire control to radar and a pressurized cabin. Here, the aircraft, its subsystems, and remarkable fuel capacity are displayed for Congress and the media at National Airport on November 29, 1944. (LC.)

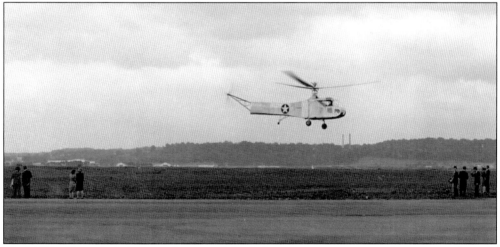

World War II marked the introduction of the helicopter into operational service, with small numbers serving in the Far East. The Vought-Sikorsky XR-4 was the first helicopter accepted by the US military and validated the type's utility. Here, the XR-4 performs a demonstration at National Airport on May 16, 1943. This aircraft may be seen in a restored condition on display at the Smithsonian Institution Steven F. Udvar-Hazy Center in Chantilly. (NARA.)

As in World War I, women provided a critical reserve of wartime labor, though the cultural legacy of their World War II service was more far-reaching as many women strove to retain their access to workplace opportunities after their wartime experience. Here, a wiring harness team installs radio connections at Marine Corps Air Station Quantico in August 1943. (NARA.)

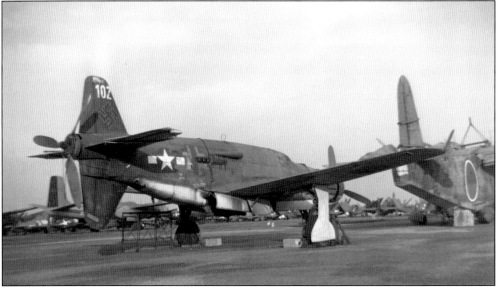

A German Dornier Do 335A-0 and a Kawanishi H8K2 "Emily" flying boat languish with other Axis and Allied aircraft at Naval Air Station Norfolk shortly after the end of World War II. The Do 335 was arguably the fastest production piston-engine fighter of World War II, but did not enter operation before the war ended. This aircraft is on display at the Smithsonian Institution Steven F. Udvar-Hazy Center in Chantilly. (NASM.)

# Five

# THE COLD WAR AND THE JET AGE

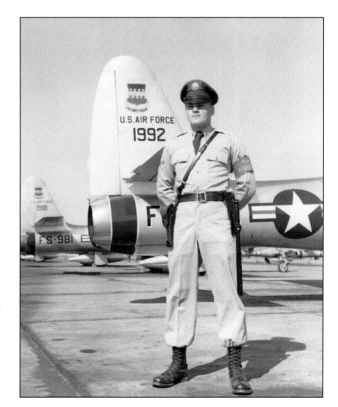

An Air Force security policeman stands watch over 20th Fighter-Bomber Wing F-84s at Langley Air Force Base in 1952. "Cold War" and "jet age" were rhetorical shorthand for a new outlook on postwar American life—one filled with technological promise for an enhanced modern life coexisting alongside fears of nuclear annihilation. If the Tidewater region stood on the front lines in the Battle of the Atlantic, all of Virginia was now a potential battleground. (NARA.)

World War II ushered in the jet age, which found the United States lagging behind its German adversary in turbine technology. By V-E Day, the United States had caught up, notably with the introduction of the Lockheed P-80 Shooting Star, which provided critical insights into the opportunities and challenges of jet aircraft. Leaving Washingtonians little doubt the jet age had arrived, 28 P-80s arrived at the Air Transport Command terminal at National Airport on May 19, 1946, for a public display. (NARA.)

Wowing the public with kerosene fumes and jet noise was one thing, retaining congressional appropriations in the face of peace was another. Here, Gen. Ira Eaker, commanding general, Army Air Forces, sells Sen. Theodore Green (D-RI, sitting) and Sen. Edwin Johnson (D-CO, standing) on the merits of continued investment in jet aircraft during the visit of 28 West Coast–based P-80s to National Airport in May 1946. (NARA.)

An officer explains the nuances of jet propulsion to an interested youngster during the May 1946 P-80 mass formation flight's arrival at National Airport. The Army Air Forces understood the importance of creating and holding public enthusiasm, particularly after 1947 with its transformation into the newly independent US Air Force. Air shows, flyovers, and base open houses were popular ways of generating public support for the service's expansion. (NARA.)

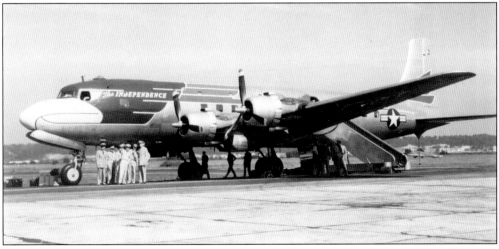

Presidential air travel did not become routine until the Truman administration. Here, Truman's personal Air Force transport, the Douglas C-118 *The Independence* prepares for departure in August 1948 at National Airport. Presidents used the Military Air Transport Service terminal at National until the introduction of the VC-137 (Boeing 707) transport in the Eisenhower administration, which required the longer runways of Andrews Air Force Base. (NARA.)

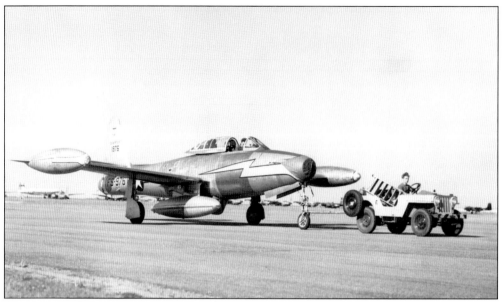

On May 16, 1952, a jeep repositions a Langley-based 20th Fighter-Bomber Wing F-84 in preparation for a United Kingdom deployment. The wing was moving to England to add to the 49th Air Division, which was a theater deterrent to Soviet ground incursions into Western Europe. The F-84 was most effective in the light strike role. Later versions were used to carry tactical nuclear weapons. (NARA.)

A North American B-45 Tornado takes hundreds of gallons of JP-1 fuel after landing at Goose Bay, Labrador, in Canada. This 47th Light Bomb Wing aircraft had departed Langley Air Force a few hours earlier, en route to Sculthorpe, England, where it was to become part of the Atomic Air Strike Force to provide nuclear interdiction against any invasion by Soviet ground forces into Western Europe. (NARA.)

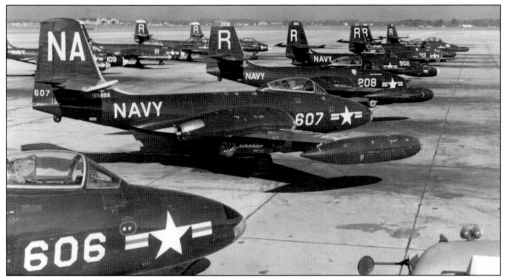

In 1952, Carrier Air Group Seventeen (CVG-17) McDonnell F2H Banshees lined up in anticipation of deployment from Naval Auxiliary Air Station Oceana to Naval Air Station Jacksonville, where they were loaded aboard the USS *Franklin D. Roosevelt* (CVA-42) to deploy for Operation Mainbrace, the first large-scale NATO naval exercise. The exercise helped define NATO control over Scandinavian waters. (NARA.)

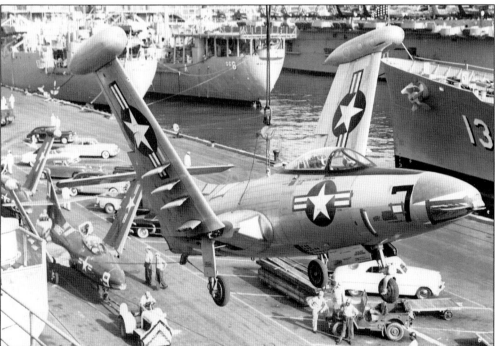

At the end of the Korean War, the USS *Palau* (CVE-122) loads Grumman F9F Panthers at Naval Base Norfolk before departing to the Far East. Early jets posed special challenges for carrier operations. Engines could be slow to respond to rapid throttle changes and World War II–era carriers lacked sufficient space with which to launch and recover aircraft as efficiently as they had with propeller-driven aircraft. (NARA.)

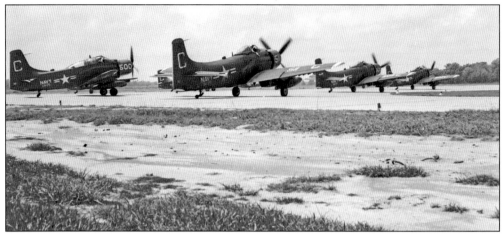

Here, Douglas AD Skyraiders begin cranking engines at Naval Auxiliary Air Station Oceana in anticipation of relocating ahead of Hurricane Diane in 1955. By 1957, Oceana was designated as a Master Jet Base, meaning that it had become one of the principal naval airfields on the East Coast. The Skyraider was beloved by ground forces during the Korean and Vietnam Wars because of its massive ordnance capacity and long loiter time. (NPL.)

On August 16, 1955, naval aviators at Naval Air Station Oceana wait out the calm before the storm as their aircraft are readied for departure in anticipation of the arrival of Hurricane Diane. Fortunately, Diane did little damage to the Tidewater region, though it caused disastrous flooding in New England. Oceana lost its diminutive "auxiliary" status in 1952 as Naval Air Station Norfolk lacked the runways required for jet operations. (NPL.)

The atomic bomb posed a special challenge to the Marine Corps as it made the conventional amphibious assault untenable against a nuclear-armed adversary. The helicopter offered the promise of being able to leapfrog enemy positions from the sea and strike at weak points in a concept known as vertical envelopment. Here, Piasecki HRP-1s of test squadron HMX-1 conduct early demonstrations of the doctrine at Quantico in 1950. (NARA.)

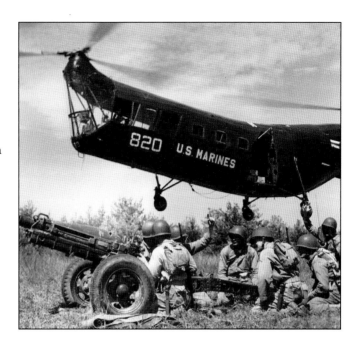

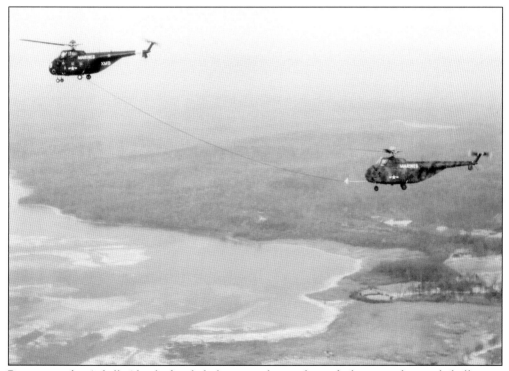

Range was the Achilles' heel of early helicopters, but midair refueling posed special challenges. These Sikorsky HRS-3s of HMX-1 demonstrate the probe and drogue method with dummy equipment in 1955 above Quantico. The domes on the rotorheads of each helicopter are the hydrogen peroxide tanks for the experimental rocket-on-rotor system to provide additional thrust for the underpowered aircraft while taking off with a full load. (NARA.)

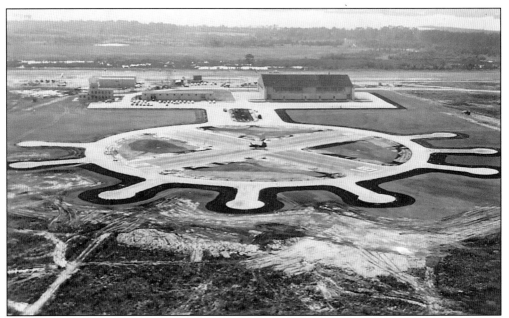

Army interest in helicopter operations also grew in the early years of the Cold War, resulting in a new type of airfield. On December 7, 1954, Fort Eustis dedicated Felkner Army Air Field, the world's first dedicated military helicopter terminal. It still required runways (albeit short) to accommodate the rolling takeoff of fully loaded wheeled helicopters, like the Piasecki H-25 seen at the center of the field. (NARA.)

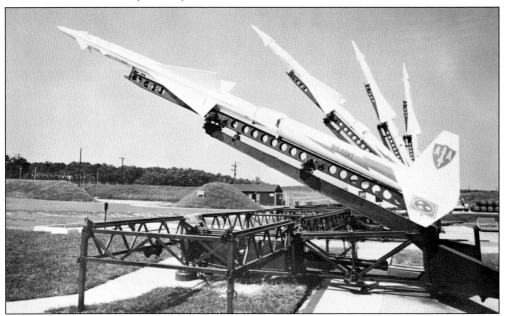

Perhaps the most distinctive Cold War additions to the built landscape of Virginia were the air defense missile sites. The most prominent of these were the Nike sites that ringed Washington. Three of them were in Virginia at Lorton (seen here in May 1955), Fairfax, and Herndon. The Nike Ajax seen here was the mainstay of the system from 1954 until the late 1950s, when it was replaced by the nuclear-tipped Nike Hercules. (NASM.)

# Six
# AEROSPACE INNOVATION WITH THE NACA AND NASA

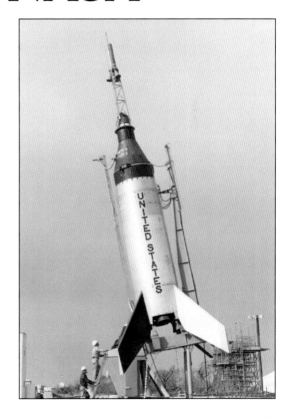

Virginia played an essential role in America's inauguration into manned spaceflight. Here, a crew prepares the McDonnell No. 14A capsule and North American Little Joe Booster LJ-5B for an April 21, 1961, launch from NASA's Wallops Station to splashdown and nearly reached 15,000 feet in altitude. Alan Shepard's first American-manned spaceflight occurred only two weeks later. (NASM.)

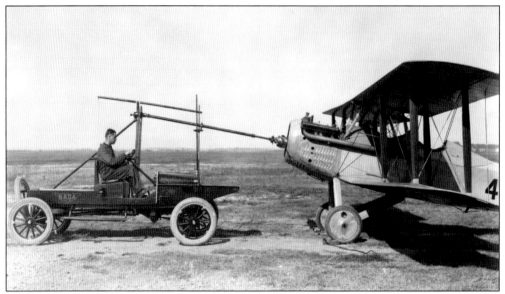

Congress founded the National Advisory Committee for Aeronautics in 1915 as part of the industrial preparedness surge in response to World War I. By 1917, its first laboratory had begun operations at Langley Field in the investigation of aerodynamics and aircraft systems. Here, a Huck starter is demonstrated on a Vought VE-7. Not a NACA invention, the starter was far safer method than "hand propping" the plane in startup. (NASA.)

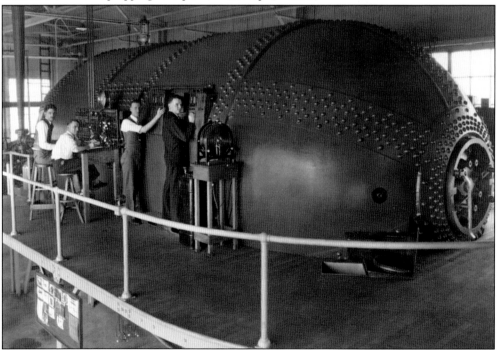

Designed by Dr. Max Munk, the Variable Density Tunnel was the NACA's first significant wind tunnel when it entered operation at Langley in 1923. The tunnel provided effective testing of the critical "NACA airfoil" shapes that helped define the science of aeronautics through the 20th century. Here, engineers and technicians pose at tunnel controls in 1929. (NASA.)

The Propeller Research Tunnel of 1927 was the next significant tunnel in operation at Langley. Designed for the evaluation of propellers, and because it created only a 20-foot diameter airflow, the tunnel was not normally used for testing full-scale aircraft. However, with the full-scale tunnel still years off, the diminutive Verville-Sperry M-1 Messenger was evaluated in the tunnel on June 22, 1927. (NASA.)

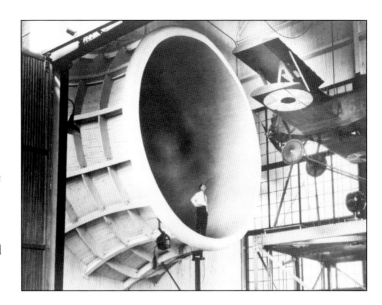

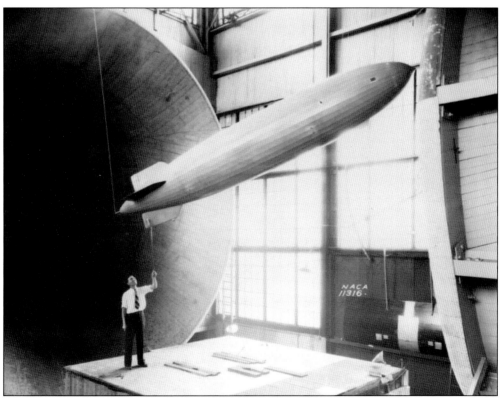

In 1935, an engineer poses with a model of the USS *Akron* (ZRS-4) in the Propeller Research Tunnel. The irony is that the Navy's rigid airship program had already ceased with the destruction of both the *Akron* and the USS *Macon* (ZRS-5). The model demonstrated the aerodynamics of rigid airships in ground handling and in proximity to airship hangars, presumably in anticipation of transatlantic zeppelin service. (NASA.)

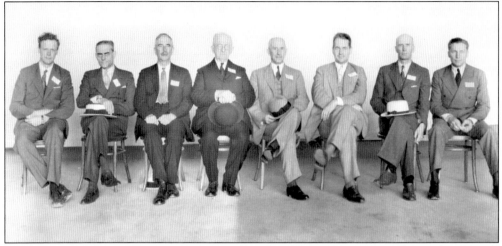

While the NACA was a large organization, the advisory committee was still at its heart, with a number of highly placed and influential personalities acting as governing board. Here, eight of the twelve committee members pose on May 23, 1934, while at the Ninth Annual Aircraft Engineering Conference at Langley. Most notable are Charles Lindbergh (left) and Orville Wright (fourth from the right). (NASA.)

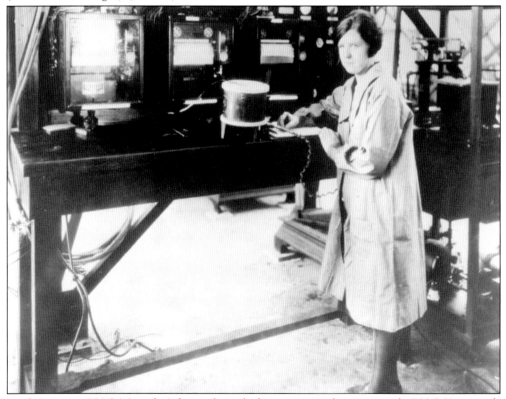

Pearl Young was NACA Langley's first technical editor—a critical position as the NACA's research was communicated principally in the form of its reports. She was the first female employee at the NACA in a technical position when she joined in 1922. She remained at Langley through most of World War II and only left the NACA after 25 years of service. (NASA.)

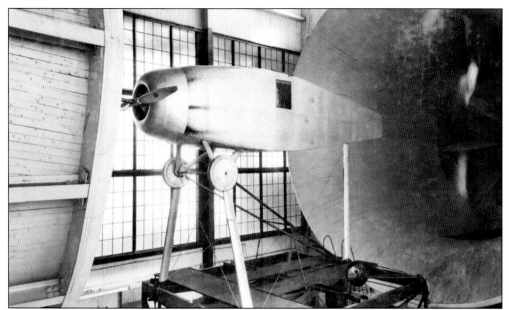

One of NACA Langley's numerous significant technical contributions of the interwar years was the "NACA cowling" that enclosed the drag-inducing shapes of radial engines, while still allowing for effective air cooling. Here, "cowling No. 10" is undergoing testing in 1927. By 1929, the NACA cowling was recognized as one of the most significant aerodynamic advances of the decade. (NASA.)

Tunnel tests were critical to new innovations, but flight tests constituted the ultimate evaluation. NACA Langley evaluated a mind-boggling array of aircraft through the decades. Here, NACA mechanics reattach a propeller to an Air Corps Fokker C-2 after mounting the NACA cowling for flight-testing on March 16, 1929. (NASA.)

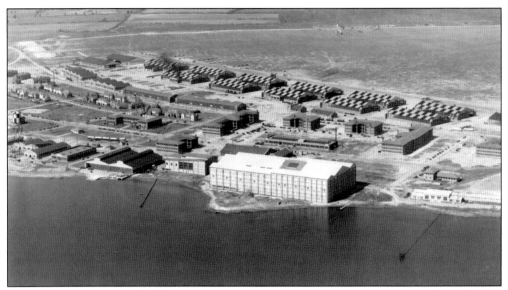

The biggest event for the NACA in the interwar years was the opening of the Full-Scale Tunnel (foreground) at Langley Field in May 1931. At that time, it was the largest wind tunnel in the world. While the Variable Density Tunnel provided engineers with critical input on new designs with models, it could not measure the impact of design details ranging from antennas and landing gear to fabric coverings. For that, they needed a full-size tunnel. (NARA.)

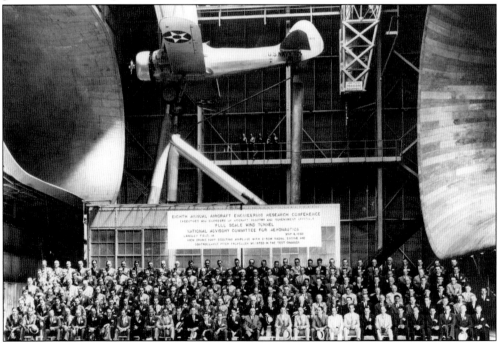

During the interwar years, the NACA was the site of annual conferences that brought together government scientists and engineers with industry and academia to consider the biggest obstacles in aircraft design and to plan investigations. Here, attendees pose in the Full-Scale Tunnel at the Eighth Annual Aircraft Engineering Conference in 1933 with the Vought XO4U-2 prototype rigged for testing. (NASM.)

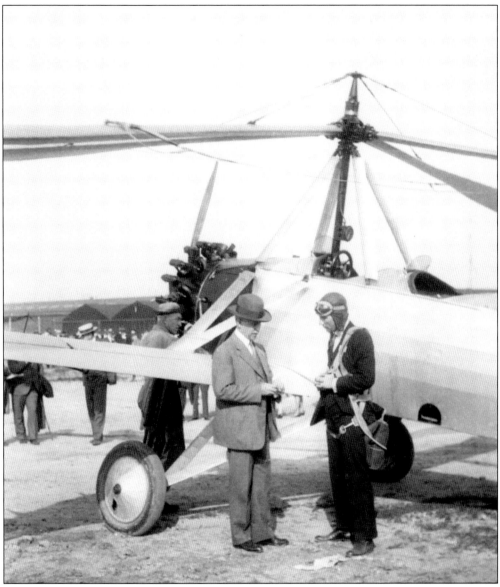

In 1928, Harold Pitcairn brought this modified Cierva C.8 Autogiro from England and flew it, marking the first flight of a practical rotorcraft in the United States. Pitcairn stunned the aviation industry by selling his profitable airline, and switching his successful line of airplane manufacturing to autogiros. What made the autogiro so attractive was that it was stall-proof and only required small, improvised fields on which to operate, seemingly ideal for the private user. Unfortunately, autogiros were enormously expensive, at prices three to five times similar capacity airplanes, which limited them as either novelties for the wealthy or flying billboards for advertisers. Pitcairn and his licensees soon saturated the market, and they struggled to survive through the 1930s. However, the autogiro laid the technical groundwork for the practical helicopter. Harold Pitcairn flew the Cierva C.8W more than 500 miles from his base at Bryn Athyn, Pennsylvania, to Langley on May 13, 1929, for the Fourth Annual Aircraft Engineering Conference. Here, Pitcairn discusses the type's virtues with Orville Wright on May 14. The Smithsonian Institution preserves this autogiro in the collection of the National Air and Space Museum. (NASM.)

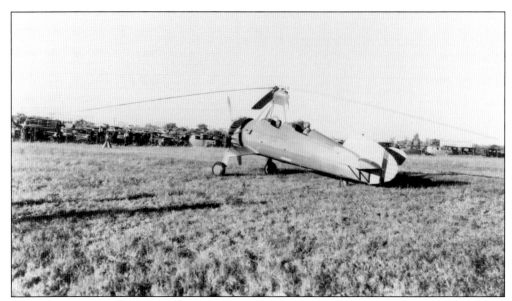

NACA engineers and much of the military were slow to embrace the autogiro, causing industry to pressure Congress for special consideration of the type. By 1936, Langley had taken delivery of two autogiros of a new generation, called direct control, in which tilting the rotorhead controlled the aircraft, unlike the earlier aileron-and-elevator-controlled models. One of these was the Pitcairn YG-2 seen here in early 1936. (NASM.)

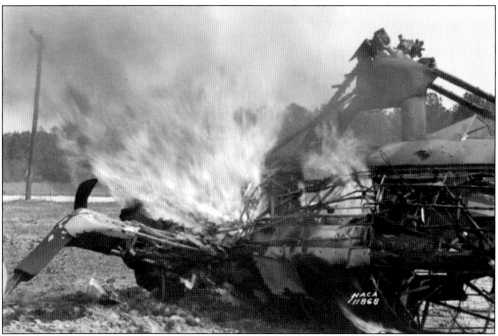

The YG-2 crashed on March 30, 1936, at Langley when improperly vented hollow rotor tips blew out in flight, causing a loss of control. Miraculously, both the pilot and observer bailed out successfully without being struck by the rotor. In November 1937, the Kellett YG-1A, another direct control autogiro, also had a catastrophic accident (caused by ground resonance) in the Full-Scale Tunnel, but no one was injured. (NASA.)

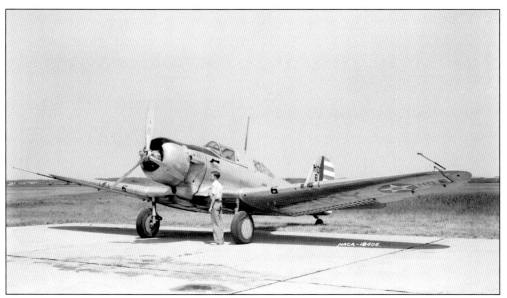

NACA Langley's importance increased as war once again approached. The laboratory was the military's primary aerodynamic research facility. Langley evaluated many of the military's aircraft in both prototype and production forms, identifying weak points and possible fixes. Here, a NACA employee poses with a Northrop A-17A Nomad on August 22, 1939, at the start of a cowling redesign program. (NASA.)

The A-17A sits on the Langley ramp on April 3, 1940, after installation of a new high-speed cowling and revised intake system. These types of investigations were essential for the development of a new generation of high-performance fighters, like the North American P-51 Mustang. The A-17 itself was largely obsolete by the start of World War II but did serve in the Canal Zone. (NASA.)

Langley sometimes tested full-scale components by mounting them on a carrying aircraft for evaluation under actual flight conditions. The NACA utilized this initial production Douglas B-18 as a testbed for a wide range of wing sections. Sometimes, this meant mounting a laminar flow section over a portion of the wing like a sleeve, or in this case (November 1941), utilizing a separate mount on the rear upper fuselage. (NASA.)

Creating accurate models for tunnel testing was a critical job as small flaws could result in large scale-effect errors. Here, young model makers craft scale representations of military aircraft for evaluation in the Spin Tunnel. The mid-engine Bell P-39 represented by the model in the foreground was plagued by problematic spin characteristics. During the war, women assumed responsibility for this task, releasing the draft-age men for service. (NASA.)

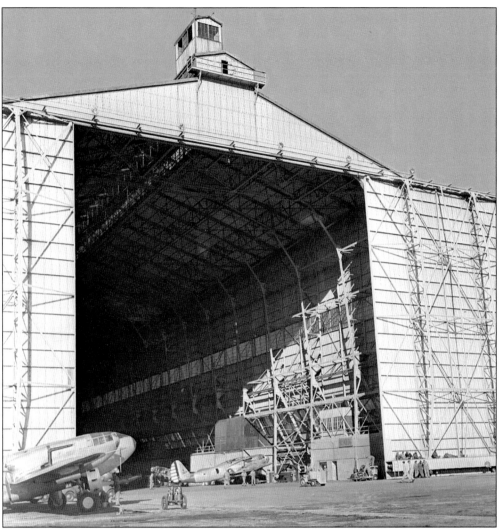

NACA Langley's facilities sat in and around the Air Corps infrastructure at Langley Field, which proved to be an important and mutually beneficial arrangement as it gave the NACA engineers ready access to a wide range of aircraft types on which to experiment. This 1940 photograph depicts a pair of Bell YFM-1 Airacudas at the Langley Field airship hangar, which had long been devoid of airships. The Airacuda is an example of shortcomings in the interdependency between the military and the NACA. While the NACA evaluated the aerodynamics of a mock-up in the Full-Scale Tunnel, it did not weigh in on the problematic design features that made the Airacuda a boondoggle. The pusher engines overheated and caused unusual stability problems. They were also prone to in-flight engine failures due to an auxiliary power unit running all electrical systems, creating a single point of failure. This type of broader systems analysis was often perceived as out of scope in the NACA's aerodynamic-centric focus, causing such issues to fall between the cracks. (DS.)

During World War II, NACA Langley played host to a wide array of American, Allied, and Axis military aircraft. This Sikorsky JRS-1 survived the attack on Pearl Harbor and arrived at Langley in 1945 where it conducted some flow visualization and hydrodynamic force tests. This aircraft is on display at the Smithsonian Institution Steven F. Udvar-Hazy Center in Chantilly. (NASA.)

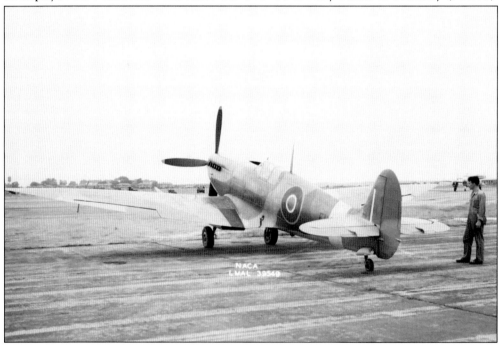

In late 1944, the NACA evaluated this high-altitude Supermarine Spitfire MK VII variant during drag studies. This aircraft is on display in the Smithsonian Institution National Air and Space Museum. The foreign aircraft that caused the most excitement among NACA engineers at this time was a recovered Mitsubishi A6M-2 "Zero" that arrived for study in May 1943. (NASA.)

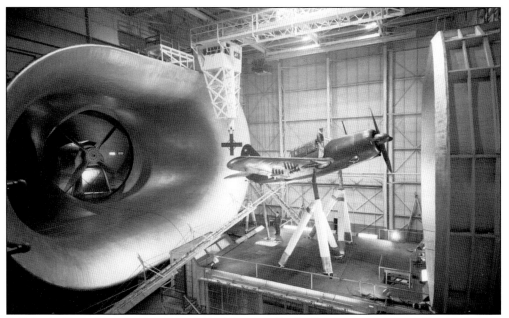

Full-Scale Tunnel tests were exciting and logistically challenging operations. Here, a Curtiss SB2C-4 Helldiver is undergoing canopy load tests at a high angle of attack, in late 1945 or early 1946. The nature of tests began changing in the early postwar era, as the tunnel was not sufficient to generate the high speeds and aerodynamic loads experienced by high-performance jet aircraft. (NASA.)

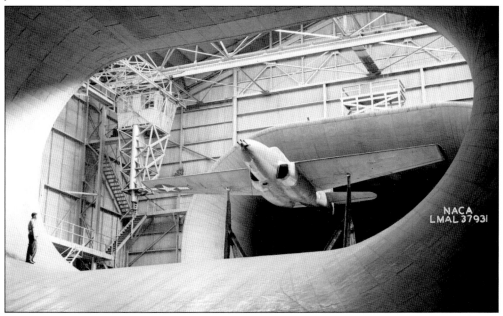

America's first jet aircraft, the Bell YP-59A Airacomet did undergo evaluation in the Full-Scale Tunnel between May and July 1944 for drag reduction in inlet and canopy design. The P-59 served its purpose in introducing the principals and nuances of jet propulsion to the Army Air Forces. It was not a viable frontline combat aircraft, which finally emerged in the form of the Lockheed P-80 Shooting Star. (NASA.)

John Stack and Ray Wright led a Langley team that had a significant impact on high-speed flight research in the early postwar period by developing the first practical transonic wind tunnel. Their "slotted-throat" research resulted in the modification of the 16-foot High-Speed Tunnel at Langley in 1950 into the 60,000-horsepower Transonic Tunnel. Here, Stack contemplates a transonic test model in 1947. (NASA.)

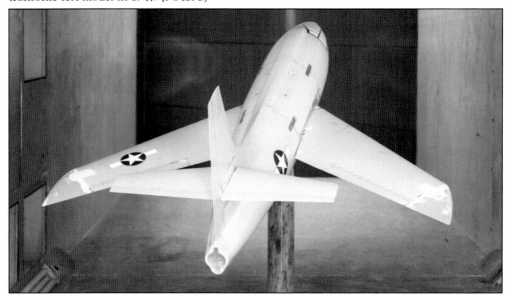

Before the Transonic Tunnel was ready in 1950, transonic studies had to occur in the existing eight-foot-high Speed Tunnel, which could marginally accommodate such tests. Here, a Bell X-1 with swept wings is undergoing test on June 17, 1947. The full-scale aircraft exceeded Mach 1 just under four months later, but with straight wings—a less-than-optimal configuration for transonic flight demonstrations. (NASA.)

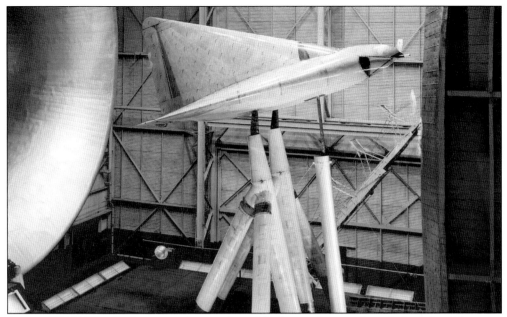

Late in World War II, Germany also conducted high-speed research including the delta-wing Lippisch DM-1. Alexander Lippisch constructed this glider as part of a larger effort toward developing supersonic aircraft in 1944–1945, but it never flew. The NACA tested the DM-1 in the Full-Scale Tunnel in 1946. It is preserved at the Smithsonian Institution Steven F. Udvar-Hazy Center in Chantilly. (NASM.)

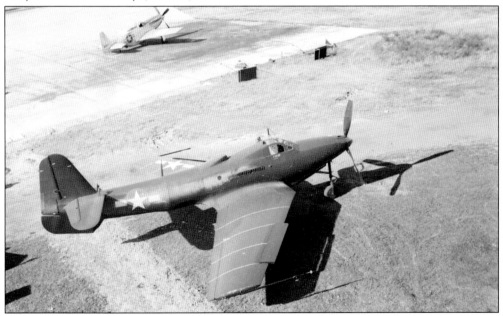

The delta wing ultimately proved critical to supersonic fighter development, but in the interim, the NACA focused primarily on the swept wing. In 1946, the Navy contracted with Bell for a swept-wing modification of the P-63 called the L-39. It demonstrated that, with leading edge wing slats, swept-wing aircraft could perform sufficiently well at carrier landing speeds. Langley began testing the second prototype in December 1946. (NASA.)

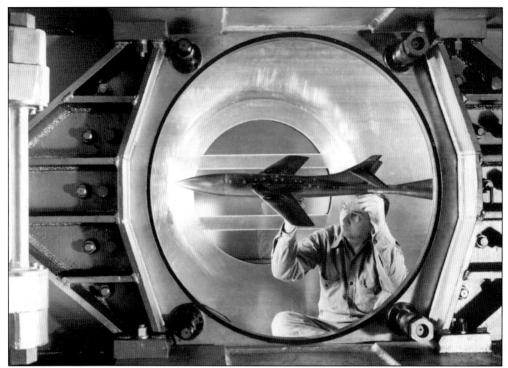

The advent of Stack and Wright's transonic tunnel improvements bore fruit with the Douglas D-558-2 program, which benefitted greatly from Langley's swept-wing studies of the late 1940s. Here, a technician prepares a model in the test cell of the four-by-four-foot Supersonic Pressure Tunnel, probably in 1948. The D-558-2 became the first aircraft to exceed Mach 2 on November 20, 1953. (NASM.)

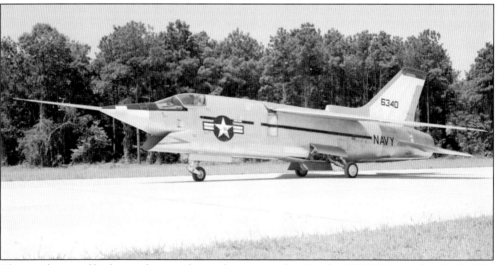

The rapid pace of high-speed research may be seen in the Vought XF8U-3 Crusader III of 1958, which was designed for combat at speeds greater than Mach 2. In operational service, it lost out to the McDonnell F4H that later became the F-4 Phantom. The cancellation of the program allowed the newly redesignated NASA Langley to employ it in high-altitude research during 1959. (NASA.)

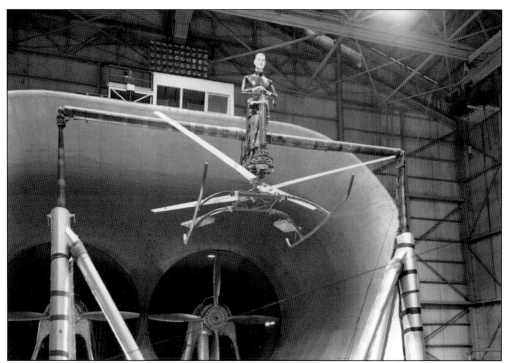

Though after the war, fewer full-scale airplanes came through the Full-Scale Tunnel due to its inability to replicate high-speed flight, it remained ideally suited for helicopters and other low-speed aircraft. One of the more unusual examples was the kinesthetically controlled de Lackner HZ-1 Aerocycle tested in July 1957. The tests were intended to discover possible instabilities that had resulted in accidents. (NASA.)

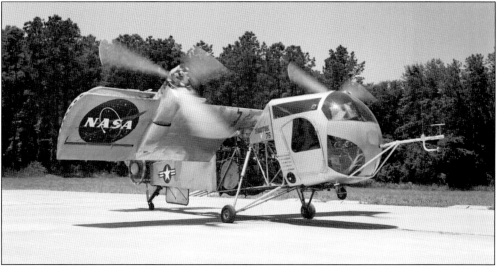

NASA's Langley Research Center managed a sophisticated Army-funded vertical-takeoff-and-landing aircraft program in the late 1950s—the Vertol VZ-2 tiltwing. A wide range of approaches to vertical flight existed at this time, and the tiltwing proved be one of the most popular through the 1960s, though it suffered from stability problems in helicopter mode. This aircraft is preserved in the collection of the Smithsonian Institution National Air and Space Museum. (NASA.)

A Marine Corps HR2S-1 recovers a Mercury test capsule during the Little Joe launch trials from Wallops Station—most likely from one of the last two launches in March and April 1961. This atmospheric test program for the Mercury capsules ran between 1959 and 1961 and consisted of eight launches, including one that catapulted a rhesus monkey named Sam to an altitude of 55 miles and brought him safely back to earth. (NASM.)

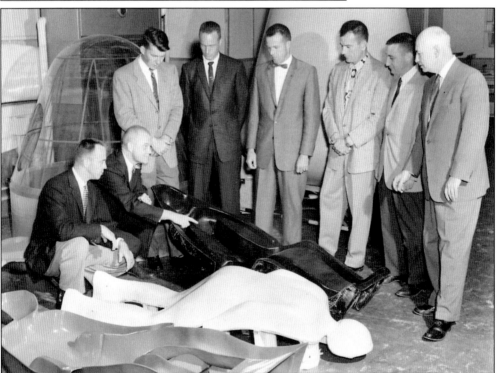

The reentry profile for the Mercury capsules exposed the astronauts to forces of nine g's under normal conditions. One solution to increasing the astronauts' tolerance to these forces and remaining conscious was the use of individually contoured couches mounted at an angle. Here, the famed Mercury Seven astronauts pose with their couches in 1959 at a Langley Research Center model shop. (NASA.)

# Seven
# FAMOUS FLIERS IN THE COMMONWEALTH

Perhaps no one better embodies the spirit of golden age aviation in the interwar years than Roscoe Turner. A handsome daredevil who performed almost every job in civil aviation at one time or another, Turner called Richmond home in the late 1920s. Here, he appears to be giving instruction in a Curtiss JN-4 Jenny at the Richmond Air Junction in 1927. (DS.)

Turner (middle) stands before his Sikorsky S-29 with what are likely Richmond city councilmen gathered for the dedication of the Richard E. Byrd Flying Field on October 15, 1927. The S-29 was an unsuccessful one-off attempt by Sikorsky to enter an emerging airline market. Turner began flying it for another owner in 1925 and purchased it in June 1927. The man on the wing is refilling the thirsty radiators. (DS.)

As tensions with Japan escalated in the late 1930s, interest in China grew exponentially. Hilda Yen was the elegant daughter of a Chinese envoy and held a pilot's license and a college education, making her a potent and appealing spokesperson for Chinese military assistance. On April 3, 1939, Porterfield Aircraft spokesman and salesman Roscoe Turner delivered a gift of a red Porterfield 35-W Flyabout named Spirit of New China to Yen at Washington-Hoover Airport. (LC.)

Renowned Pitcairn Aviation pilot Dick Merrill poses in his Pitcairn Mailwing at Richmond's Richard E. Byrd Flying Field, sometime in 1929–1930. Merrill made his name flying the night mail on Contract Airmail Route No. 19 between New York and Atlanta, which started December 1, 1928. Merrill stayed with the company when it became Eastern Air Transport and, later, Eastern Air Lines. He gained a reputation as one of the company's safest and most deliberate pilots and became a favorite of company president Eddie Rickenbacker. His fame grew considerably in 1936 when he flew a borrowed Vultee V-1-A from New York to London and then promptly back again, along with entertainer Harry Richman. Merrill then married movie star Toby Wing and began moving in Hollywood circles while retaining his airline job. He flew as Eisenhower's personal pilot in his 1952 campaign. He was one of a select few aviators who could claim that they started their career flying a Curtiss JN-4 Jenny and ended it with a Douglas DC-8 jetliner on transatlantic hops. (DS.)

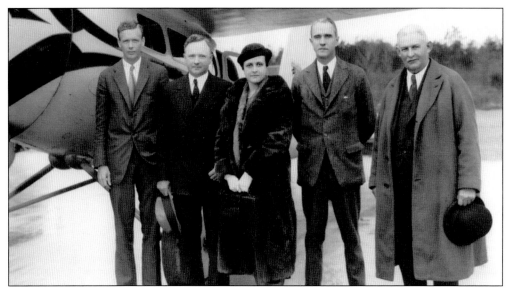

Charles Lindbergh (left) was a frequent visitor to the commonwealth, spending considerable time at NACA Langley. Here, he is paying his respects to Virginia governor Harry F. Byrd and his wife, Anne, pictured second and third from the left, around 1929. Not long before his passing in September 1930, Daniel Guggenheim is seen standing on the right. Guggenheim did more to promote American aviation in the 1920s than any other private citizen. The man second from right is unidentified. (DS.)

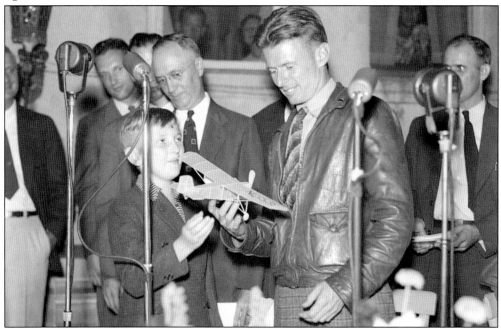

A young admirer presents Douglas "Wrong Way" Corrigan with a model of his Curtiss Robertson OX-5 Robin *Sunshine* at a dinner in his honor at the Nansemond Hotel in Norfolk on August 30, 1938. The previous month, Corrigan made his name by illegally flying from New York to Ireland in his rickety Robin; he claimed a navigational error after the government disapproved his planned transatlantic flight. The exploit made him the most popular folk hero of the day. (NPL.)

A pensive Beryl Hart stands with her copilot and instructor, William MacLaren, by their Bellanca J-2 Special *Tradewind* at Naval Air Station Norfolk on January 4, 1931. She wanted to become the first woman to cross the Atlantic as pilot-in-command as well as demonstrating the possibilities of commercial transoceanic flight. They had just attempted to fly from New York to Paris via Bermuda and the Azores, but became lost off the East Coast and turned west out of desperation, finding their way to Norfolk. Neither Hart nor MacLaren was particularly skilled in the art of navigation, and MacLaren dropped and damaged their sextant in flight. They made another attempt three days later with a new sextant and successfully made landfall in Bermuda. Unfortunately, they were not seen again after departing for the Azores. The honor that Hart so desperately sought went to Amelia Earhart the following year. (NPL.)

Amelia Earhart stands next to Dr. Gilbert Grosvenor, president of the National Geographic Society, at Washington-Hoover Airport on June 21, 1932. The occasion was somewhat awkward as she had originally planned on arriving in Washington to receive the Distinguished Flying Cross from Pres. Herbert Hoover in recognition of her solo transatlantic flight the previous month. However, congressional debate held up the honor, so Dr. Grosvenor hurriedly arranged the awarding of the National Geographic Society's gold medal from Hoover instead. She finally received the Distinguished Flying Cross a month later at the Los Angeles Olympics from Vice Pres. Charles Curtis. Earhart and Grosvenor are standing in front of Ludington Lines Lockheed Vega. Earhart served as a Ludington Line vice president, and Charles Ludington held the lease on Hoover Field. (LC.)

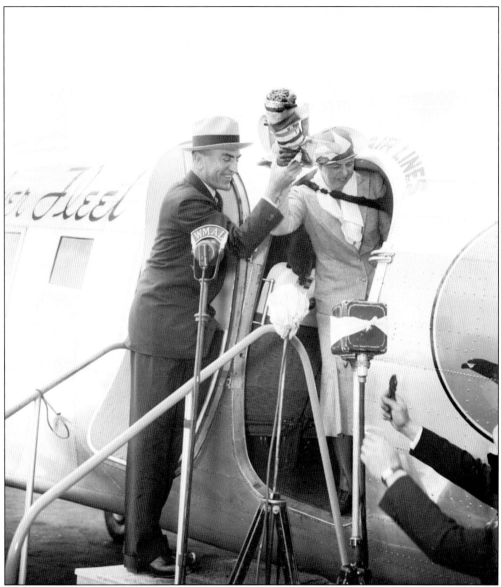

On May 17, 1937, First Lady Eleanor Roosevelt christens the new Eastern Air Lines Douglas DC-3 New York-to-Washington shuttle service with Eastern president Eddie Rickenbacker at Washington-Hoover Airport. The service ran hourly from 8:00 a.m. to midnight. By 1937, passenger air service was beginning to replace rail service for some of the more prominent government and business travelers, whereas before the airlines had catered largely to wealthy elites. The Roosevelts played a critical role in the growth of American aviation. Both Franklin and Eleanor were entranced by flight and worked to promote aeronautics. FDR's contributions included pushing the Works Progress Administration (WPA) to support airport development, advancing the Civil Aeronautics Act that established the Civil Aeronautics Board (CAB) and Civil Aviation Administration (CAA), and personally leading the charge to construct National Airport. While the WPA had assisted localities with federal support of airport development, Roosevelt was proposing a massive shift in federal funding by having the government undertake development of National Airport. This required extensive pressure on Congress to alter its rules. (LC.)

Sister Mary Aquinas Kinskey gained notoriety as the "flying nun" in 1943 for learning to fly in her nun's habit and for teaching ground school classes to future combat pilots at Catholic University. Here, she explains the basics of a radial engine to other members of her order at National Airport. They, in turn, taught ground school lessons at area schools to speed training of new enlistees. Sister Aquinas kept flying after the war and wrangled "stick time" in a number of aircraft ranging from helicopters to C-119 transports to jet trainers, as well as B-52 and B-58 simulators. She was sorely disappointed in 1959 when she was denied the opportunity to break the sound barrier in an Air Force jet because she would not trade the habit for a G suit. She was still teaching aeronautics classes at Loyola into her sixties. (LC.)

## Eight

# GENERAL AVIATION AND THE PRIVATE PILOT

In the craze to imitate the Wrights, Glenn Curtiss, Louis Blériot, and other paragons of early powered flight, numbers of now forgotten designers and builders tried to one-up their sources of inspiration with their own designs. In most cases, the results were like this questionable design seen at Lee's Parade Grounds at the former site of the Jamestown Exposition (now Norfolk Naval Air Station) in 1910 or 1911. (NPL.)

An unidentified early barnstormer's Curtiss Pusher copy sits on Lee's Parade Grounds in 1912. By this time, most demonstration pilots had given up on their own designs and copied successful examples. By giving demonstrations and rides, fairs were rich ground for those who could afford their own aircraft. Barnstorming became more literal as pilots moved into rural areas to find people who had never seen a plane up close. (NPL.)

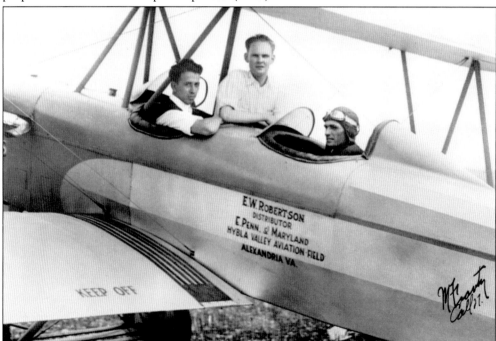

Lindbergh's solo crossing of the Atlantic in 1927 and economic boom times created a surge of interest in private flying in the United States, and many small schools and airports popped up to meet the demand. Elvin Robertson was one such proprietor. He established the Hybla Valley Aviation Field near Mount Vernon, instructing in this Alexander Eaglerock. He unfortunately became entangled with the huckster Henry Woodhouse (see page 109). (VAHS.)

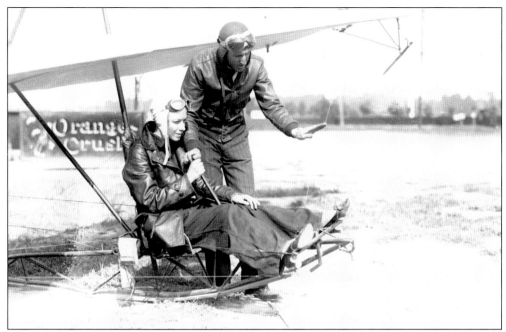

A new student learns flight control basics from her instructor while sitting in a primary glider at Virginia Beach in the early 1930s. The airport is not identified but may be Hudgins Field. In the flat terrain of the Tidewater, the only value of an obsolete glider like this was in static instruction. (NPL.)

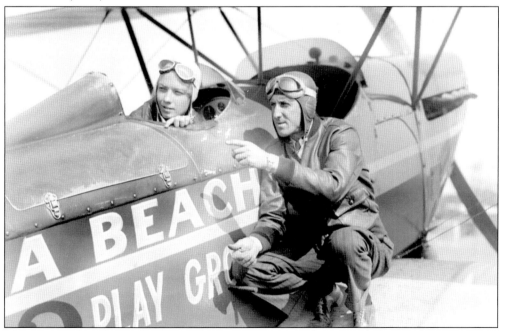

The same unidentified student receives basic instruction in the parts of the aircraft. The airplane is a Brunner-Winkle Bird equipped with an OX-5 engine. The Bird was an excellent basic trainer of the late 1920s with good short-field performance and was considered a safe airplane with a high crashworthiness standard. (NPL.)

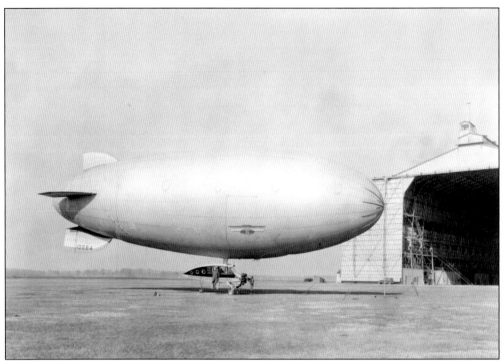

The hydrogen-filled Heinen Air Yacht prepares for takeoff in front of Langley's airship shed in the summer of 1931. One of the few blimps ever marketed for private use, it could carry a pilot and three passengers with a purchase cost similar to a new car. Anton Heinen, a former zeppelin captain, saw a need for a family airship and constructed the Air Yacht in New Jersey. (NARA.)

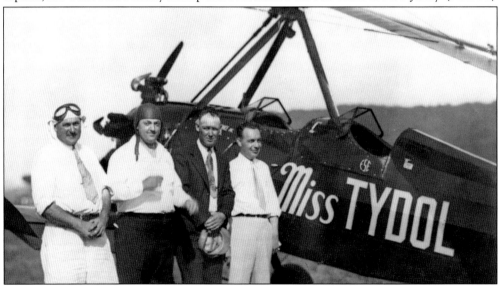

Photographed around 1932, Earle Eckel (left) stands with three unidentified gentlemen next to his Pitcairn PAA-1 autogiro (NC11631) *Miss Tydol*. The location is probably Charles Field northwest of Richmond. Eckel was one of the most active civil autogiro pilots of the 1930s and used his close association with oil companies to acquire an advertising contract for Tydol gas, which he used to finance his barnstorming on the East Coast. (VAHS.)

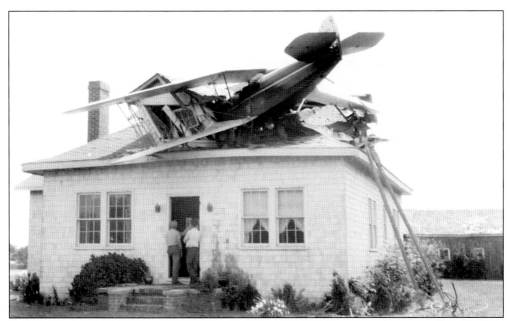

On May 5, 1933, Mrs. George Christopolous was outside her home in Chesapeake Beach while her daughter and a friend were inside. C.O. Smith, flying with his passenger, William L. Holland, then crashed his Travel Air into the second floor for unknown reasons. No one in the home was injured. (NPL.)

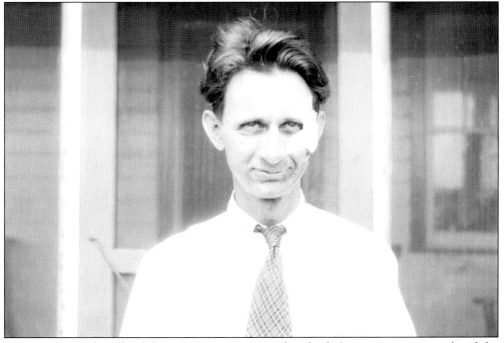

Fortunately, Smith suffered the only injury—a cut on his cheek. Insurance estimates placed the damage to the home at $200 and the damage to the plane at $500. The limited damage is an indication that the aircraft was flying slowly and may have been trying to make a forced landing after an engine failure. (NPL.)

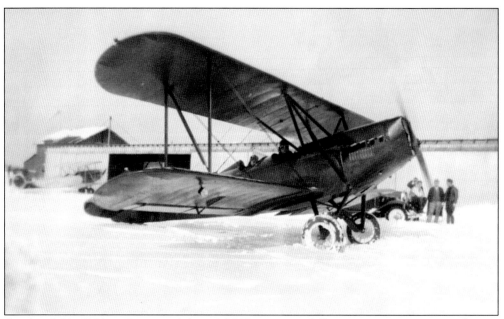

On April 21, 1934, a Command-Aire 3C3-T unsuccessfully attempts to taxi out after an unseasonably late snowstorm at Beacon Hill airport south of Alexandria. Beacon Hill was a popular general aviation field from its inception in the late 1920s to its closure in 1959. It suffered the same fate shared by many other small Northern Virginia airfields when the Beacon Hill Mall replaced it. (VAHS.)

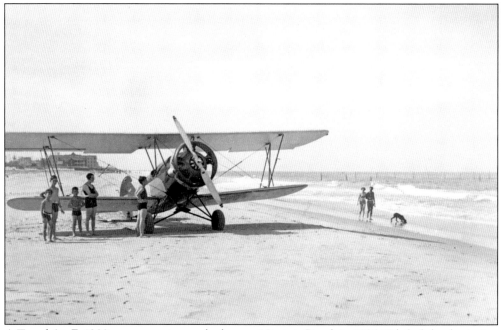

A Travel Air E-4000 attracts curious onlookers on Virginia Beach in 1935. While federal aviation regulations today prevent most public beach landings, such activities were tolerated to a greater extent in the prewar years. The E-4000 was a popular advanced-training plane developed in the late 1920s and had a useful load of at least 1,000 pounds. (NPL.)

Just as the airplane was a powerful tool for visionaries who saw it benefiting all humanity, so too was it useful for those who embraced hate and intolerance. The Ku Klux Klan operated several aircraft during its popular resurgence in the 1920s, including this war-surplus Curtiss JN-4 "Jenny," which was about to be employed to drop leaflets for an impending march on March 18, 1922, in Northern Virginia. (LC.)

In the late 1940s, a Luscombe Silvaire photographed by Hans Groenhoff sits parked at the Warrenton Hunt races. Groenhoff (1906–1985) was one of the most prolific and accomplished American aviation photographers. He made his living supplying photographs to popular aviation periodicals. Luscombes were popular aircraft for the so-called sportsmen pilots who enjoyed venturing out to more remote fields. (NASM.)

Louise Thaden (left) and her daughter Pat (right) prepare to depart Roanoke for the 1950 International Women's Air Race in her Taylorcraft *Fashion Trend*. Her sponsor, Don L. Jordan, president of Johnson-Carper Furniture Company, looks over their flight planning. Thaden had a long and distinguished air derby career and was best known for winning the Bendix Trophy Race in 1936—the first year women were allowed to enter. (NASM.)

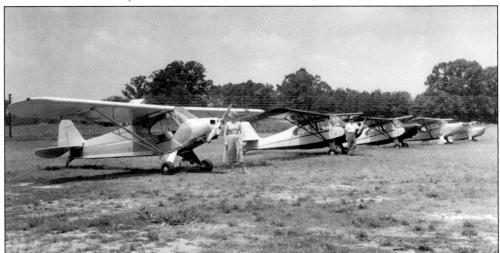

The 1950s were the heyday of grass-runway, general-aviation airports in Virginia. This line-up of light aircraft, including a Piper PA-11 and several PA-12s, appeared in 1955 at William & Mary Airport, later known as Central Airport, which closed in 1967. Such fields depended heavily on proprietors who were vested in the maintenance of site out of love rather than money (because there was little to be made). (VAHS.)

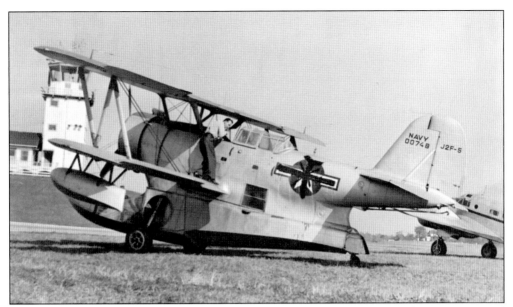

*Warbirds* is the term for former military aircraft adapted for civilian use. One of the more unusual examples is this Grumman J2F-5 Duck amphibian seen on the ramp at Lynchburg in the late 1940s. The national insignia has been crudely painted out. This former Navy scout used on battleships would have been an awkward aircraft to employ in domestic use in the eastern United States. (VAHS.)

One of the most exotic warbirds in the early postwar years was the Bell P-59 Airacomet, the nation's first jet. The Navy supplied it, and the Curtiss SO3C behind it, to the Technical Institute of the College of William & Mary, Norfolk Division (now Old Dominion University). Here, on May 31, 1950, students appear to be preparing to run up the engines, presumably much to the annoyance of the nearby residents. (NPL.)

One of the most unusual general aviation aircraft operated in Virginia is seen here at Bailey's Crossroads Airport, probably in the late 1940s. The plane is the one-off Fairchild F-46 made in the late 1930s as a demonstration for the composite Duramold process later used in construction of the Hughes H-4 Hercules *Spruce Goose*. (VAHS.)

Bailey's Crossroads Airport, later known as Washington-Virginia Airport endured the same boom-and-bust cycle of many Virginia airports. In the early postwar years, the proliferation of general aviation and cheap land resulted in the founding of many new private airports. Suburban sprawl subsumed many of them in the 1960s, including this one, which closed in 1970. A strip mall has since covered all trace of it. (VAHS.)

# Nine
# COMMERCE ON THE AIRWAYS

In 1929, Henry Woodhouse held an inauguration for a large parcel of land near Mount Vernon that he called the George Washington Air Junction, presented as Washington's future primary airport and international terminal for transatlantic zeppelins. Woodhouse was by most accounts a charlatan, and the stock market crash sealed the project's fate. The episode was emblematic of the difficulties experienced in creating a viable air terminal for Washington. (NASM.)

What is now Richmond International Airport had its beginnings on January 20, 1927, when future celebrity aviator Roscoe Turner located the site on behalf of the Richmond City Council. The resulting Richmond Air Junction was well suited for expansion. Aircraft like the Curtiss JN-4, seen here, were hopelessly obsolete by this time, even for basic training. It sits next to the short-lived operations building. (DS.)

Turner (moustache, standing center) was the soul of the Richmond Air Junction for its first year. On October 15, 1927, the Richmond City Council renamed it the Richard E. Byrd Flying Field, for the famed polar explorer. Turner's time in Richmond was brief as his fame grew. With his movie star looks and showman's personality, he was just the type of escapist personality who did well in Depression-era America. (DS.)

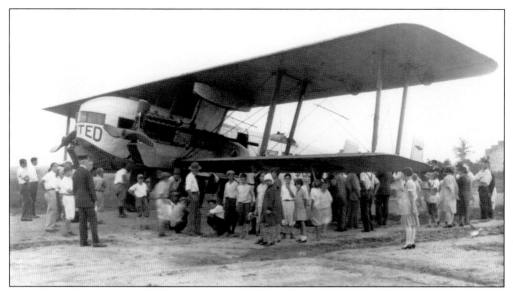

Turner's Sikorsky S-29 attracts a crowd at the Richard E. Byrd Flying Field dedication in the markings of the United Cigar Company, for which he flew it as a flying cigar store! In February 1928, he flew it to California for Howard Hughes's epic *Hell's Angels*. He then sold it in April to Hughes, who had it crashed in a stunt for the film a year later—unfortunately with a fatality. (DS.)

A Pitcairn Aviation pilot poses with a cup of coffee beside his Pitcairn Mailwing at a stop in Richmond's Byrd Field. This was probably taken in conjunction with the inauguration of Contract Airmail Route No. 19 overnight service from New York to Atlanta in 1928. The following year, company founder Harold Pitcairn sold his airline, which became Eastern Air Transport, in order to pursue autogiro manufacturing. (VAHS.)

The lumbering Curtiss Condor Model 18, seen here at Byrd Field, was a mainstay of Eastern Air Transport service from New York in the early 1930s. The cabin seated 18 comfortably and even featured a lavatory with running water. Faster and more luxurious than the Ford and Fokker trimotors that it replaced, its time in service was short as all-aluminum monoplanes with retractable gear quickly eclipsed its performance. (DS.)

The mammoth Dornier Do X flies over Norfolk on August 16, 1931. When developed in the late 1920s as the first practical purpose-built transoceanic airliner, the Do X was an engineering marvel, but the fast pace of aeronautical technology rapidly eclipsed it. The inaugural transoceanic crossing from Germany to the United States was a debacle, with numerous setbacks that only underscored the impracticality of transatlantic service with the aircraft. (NARA.)

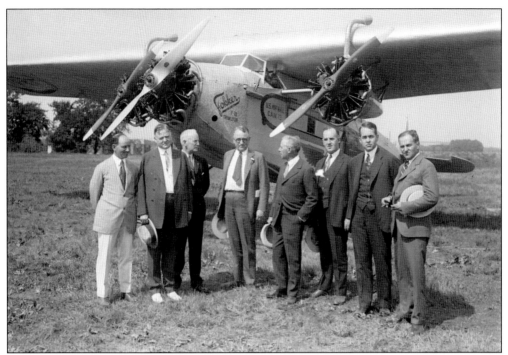

Pres. Herbert Hoover (second from left) stands by a Philadelphia Rapid Transit Company Fokker F.VII trimotor for the inauguration of Hoover Field on July 16, 1926. Thomas Mitten founded the airport and airline as an adjunct to his surface transport empire in conjunction with the Philadelphia sesquicentennial exposition. PRT ran airmail and passengers between Philadelphia and Norfolk via the new airport but quickly foundered and was bankrupt by November. (LC.)

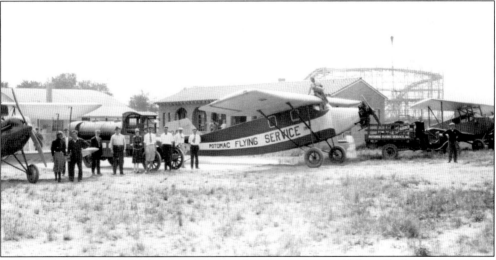

With the failure of Philadelphia Rapid Transit, local aircraft mogul Henry Berliner acquired the infrastructure of Hoover Field and established Potomac Flying Service. Adjacent to the south, and separated by Military Road, sat Washington Airport. The two fields competed for Washington's air traffic until tentatively merged in 1930 as the Washington-Hoover Airport. The Arlington Beach amusement park in the background was demolished as Washington Airport expanded in 1929. (NASM.)

The new Washington Airport terminal-and-administration building was photographed around the time of its opening in 1930. At the time, Congress was encouraging the airport to combine with adjacent Hoover Field and the Department of Agriculture Experimental Farm to the west, resulting in a reasonably spacious airport for the latest transport aircraft. Even then, this was understood as only a temporary measure and that a new airport for the capital would soon be needed. (NASM.)

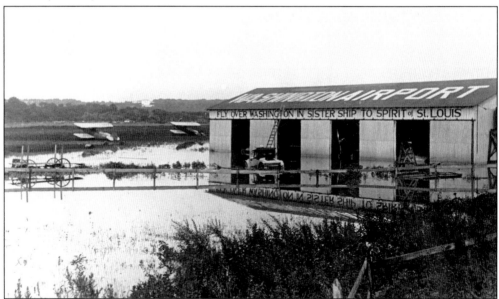

Adjacent Washington Airport and Hoover Field suffered repeatedly from flooding, which contributed to their generally negative perception by Washingtonians and visitors alike. The sign on the hangar refers to a four-seat Ryan Brougham operated by the Washington–New York Air Line, which was similar in construction to the Ryan NYP *Spirit of St. Louis* flown by Charles Lindbergh across the Atlantic in 1927. Sightseeing tours supplemented the company's charter service. (NASM.)

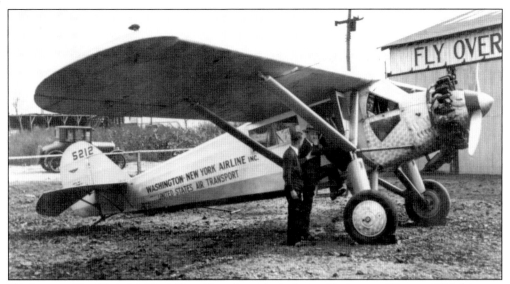

Washington-New York Air Line's Ryan Brougham sits in front of its hangar. The small Washington Airport operation was in business for less than a year before US Air Transport, which replaced the Ryan Brougham with the Lockheed Vega, bought it out. The new owner then promptly went bankrupt in the face of the Depression. (NASM.)

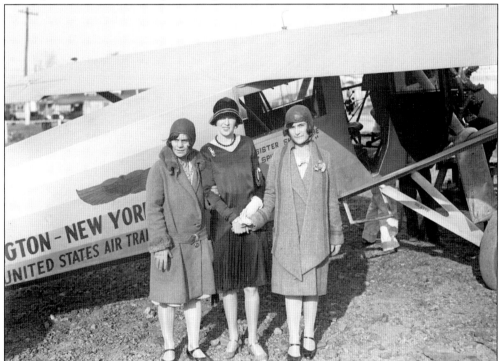

Three women prepare to board Washington–New York Air Line's Ryan Brougham in 1928–1929. Seaboard Airways, a competing venture at Washington Airport, briefly provided service directly to Manhattan with three float-equipped Ryan Broughams. These aircraft were operating in a charter, rather than scheduled, service. Undoubtedly, the plane's similarity to the *Spirit of St. Louis* convinced many otherwise reluctant passengers to take flight. (LC.)

In April 1930, members of the Washington Women's City Club ventured to Washington-Hoover to see airport operations. Here, two of them pose beside what may be M.E. Zeller's Ford Trimotor flown on the 1929 National Air Tour. The tour was meant to showcase the reliability of commercial aircraft types. Although the Ford Trimotor was an uncomfortable plane in which to be a passenger, it was generally safe and reliable. (LC.)

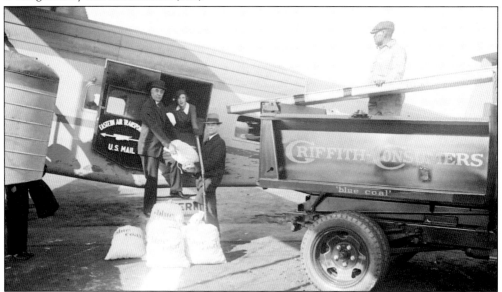

An unusual ground crew unloads "blue coal" from an Eastern Air Transport Curtiss Condor at Washington-Hoover on November 11, 1932. This settled a debt made by Bascom Slemp, Calvin Coolidge's former secretary, with John Costello, chairman of the Democratic Committee of the District of Columbia, over the outcome of the 1932 presidential election. It took two planeloads to deliver the one ton of Pennsylvania-mined anthracite from Camden, New Jersey. (LC.)

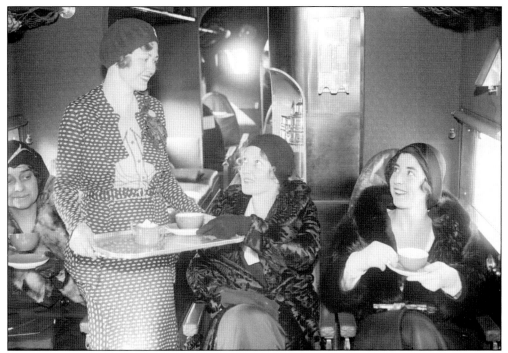

Miss Wanda Wood serves tea as an Eastern Air Transport hostess on a Curtiss Condor, operating out of Washington Airport, on January 10, 1930. The airline did not serve food, just tea and cigarettes, as well as providing bridge games. The lumbering steel-tube and fabric Condor had a comfortable interior compared with its successors like the speedy Boeing 247. However, the slow Condors were hopelessly obsolete by the mid-1930s. (LC.)

The *Detroit News*' Lockheed 9-D Orion *Early Bird* sits by the old Potomac Flying Service hangars at Washington-Hoover in the mid-1930s. The Orion represented a new breed of fast, streamlined, all-metal monoplanes when it debuted in 1931. Used by both corporations and airlines, it was 30 percent faster than the Curtiss Condor and improved airline performance until the advent of the Boeing 247 in 1933. (NASM.)

An unidentified couple and possible mother-in-law prepare to board a Central Airlines Stinson Model A trimotor at Washington-Hoover in 1936. Compared with the stressed skin, retractable gear Boeing 247s and Douglas DC-2s, it was obsolete, but the fabric-covered Model A was still an effective airliner for routes with smaller loads. By 1936, Washington-Hoover had acquired a terrible reputation. Military Road that had previously separated Hoover Field and Washington Airport was still in service after their consolidation, and it intersected the main runway. Sirens, chains, flagmen, and traffic lights were all tried to separate cars and planes, but the situation was intolerable, especially when combined with the frequent flooding, a nearby burning landfill, and an ever-increasing array of surrounding smokestacks and towers. Famed world flier Wiley Post noted that he had seen better airfields in Siberia. Calls for a new National Airport began in earnest by 1933, but sufficient resources were not available until 1938, when Pres. Franklin Roosevelt became personally invested in the new airport. (LC.)

In 1935, as part of the 25th anniversary of the founding of the Boy Scouts, an American Airlines Douglas DC-2 captain receives a token of thanks from two Scouts on a snowy January day at Washington-Hoover Airport. He had just taken them and other Scouts on an aerial tour around Washington. (LC.)

On January 16, 1935, World War I ace and Eastern Air Lines president Eddie Rickenbacker took Edith Wilson (second from right), widow of the former president, for her first airplane ride in one of the company's DC-3s at the Washington-Hoover Airport. Also attending were Rickenbacker's wife, Adelaide (left); Agnes Myer (second from left); and stowaway Marie Reynolds, who wanted to write about the episode for her college paper. (LC.)

Civil War veterans prepare to board a Pennsylvania Central Airlines Boeing 247 at Washington-Hoover on Memorial Day 1938 to drop flowers over Arlington National Cemetery. William Jackson (left) served the Union in noncombat duty while Robert Wilson (on the steps) fought as a Confederate cavalryman. H.C. Rizer (second from right) commanded a Union regiment, and Peter Smith (right) fought under Lee and Jackson. (LC.)

Bedell Monroe, president of Pennsylvania Central Airlines, holds a microphone as one of his Boeing 247s prepares to takeoff with Civil War veterans William Jackson (left) and Robert Wilson (right). This was their second flight of the day. On the first, they dropped flowers over Arlington National Cemetery. On this flight, they had hoped to tour Gettysburg by air, but weather kept them from getting any closer than Antietam. (LC.)

Sen. William Smathers (D-NJ) prepares to board a Miami-bound plane at Washington-Hoover on February 29, 1938, for his honeymoon. His wife, Mary Foley, walks on his right while his mother, aunt, and son escort them. Washington's airport had obtained a nationally dismal reputation for being too small, prone to flooding, and possibly dangerous. Plans were underway to infill a new airport site on the Potomac at Gravelly Point. (LC.)

On October 4, 1938, the chefs of Washington's top-six hotels posed with Eastern Air Lines hostess Marjorie McKinnon to promote National Air Travel Week with special desserts for select outgoing aircraft. The limited size of medium-haul airliners, like this Douglas DC-3, kept the standards of food service low. The unpressurized airliners also flew at lowers altitudes with more turbulent air, making airsickness common. (LC.)

The Goodyear airship *Enterprise* arrived at Washington-Hoover in late 1934 and was a frequent denizen of Goodyear's airship hangar at the northeastern corner of the airfield. The *Enterprise* was a fixture over Washington, DC, through the late 1930s. It was the first aircraft to land at Washington National and the last to leave Washington-Hoover. Its control car is on display at the Smithsonian Institution Steven F. Udvar-Hazy Center in Chantilly. (LC.)

President Roosevelt appointed Col. Sumpter Smith as chairman of the Washington National Airport Commission. On December 2, 1939, he showed off a model of the National Airport terminal to the press. The 750-acre airport had everything that Washington-Hoover did not, including nonobstructed departure and arrival corridors. Passengers also benefitted from an unprecedented array of amenities, including dining rooms and coffee shops. Only New York's LaGuardia could compare in grandeur. (LC.)

The grand opening ceremony of National Airport on June 16, 1941, marked an important new phase of growth in Washington, DC. Not only was the new airport the grandest in the nation, but it also meant that the site of the dangerous and decrepit Washington-Hoover could now be utilized for the Departments of War and Navy's new home at the Pentagon. (NASM.)

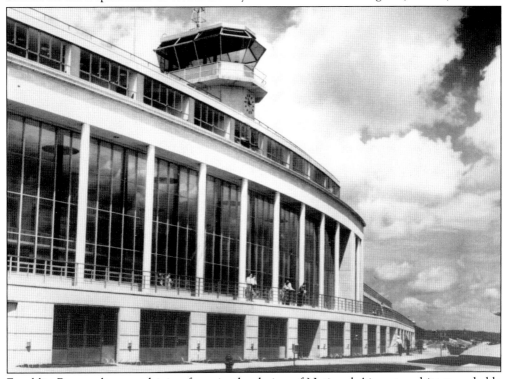

Franklin Roosevelt was a driving force in the design of National Airport and its remarkable modern terminal. Lead architect Howard Cheney, assisted by Charles Goodman, was pressured by the Roosevelt administration to incorporate elements reminiscent of Mount Vernon. Regardless of its origin, the outcome was effective, with the ramp-facing facade looking out onto the vista of an airpark that drew nonflying tourists. (NASM.)

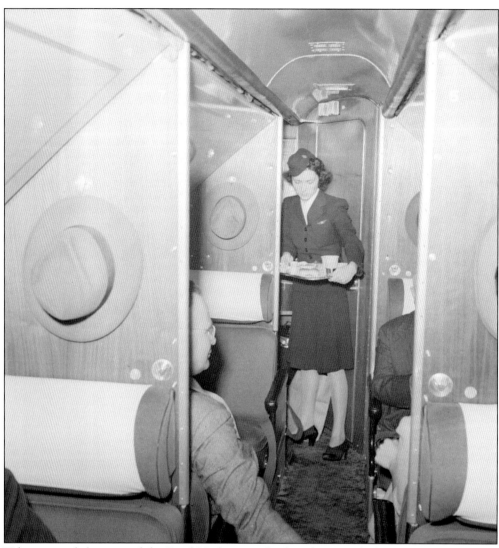

Taken around the time of the Pearl Harbor attack, this photograph documents a stewardess serving a meal on an American Airlines flight out of Washington National bound for Los Angeles. This is a DST (Douglas Sleeper Transport)—a DC-3 with 14 seats that converted into seven small sleeping cabins with bunk beds. The flight took slightly more than 18 hours and included 12 stops en route. With increasing speed, and a demand for greater economy through increased capacity, sleeper cabins rapidly disappeared from airliners. World War II accelerated and disrupted the commercial airline revolution. While military production disrupted commercial aircraft manufacturing, military technologies like the jet engine had enormous consequences for the future of air travel. Many commercial aircraft that were on the verge of entering commercial service on the eve of Pearl Harbor, like the Lockheed Constellation or Douglas DC-4, were instead implemented as military transports. Some models like the Boeing 377 Stratocruiser emerged out of military programs. Perhaps the most significant wartime benefit for civil aviation was the massive investment in airport and airway infrastructure around the globe. (LC.)

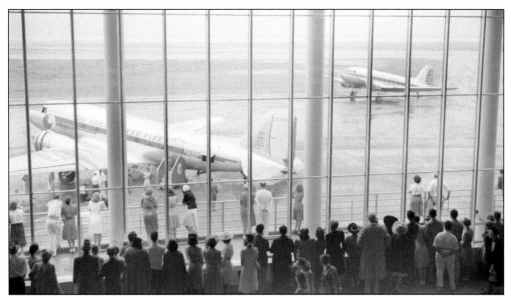

In the months after the opening of Washington National's spectacular new terminal on June 16, 1941, visitors flocked to it for the pleasure of simply watching the aircraft arrive and depart. They could view the comings and goings of the ramp in the air-conditioned comfort of the massive galleries with their expansive glass-curtain wall, or they could venture outside to an open-air balcony. (LC.)

Nighttime did not dampen the ardor of the Washington-area crowds that came to see the movement of airliners arriving and departing Washington National in the languid summer before America's entry into World War II. Nearly all of the airliners at the time were Douglas DC-3s. War changed the character of the airport significantly as the military terminal attracted a much greater array of aircraft. (LC.)

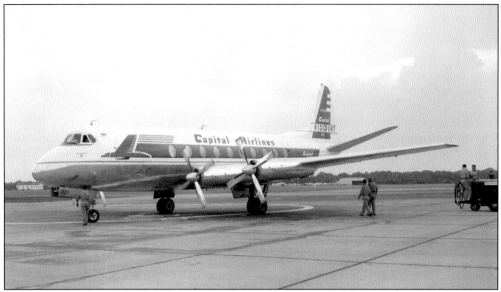

The end of World War II brought the jet age, including the British-built Vickers Viscount seen here, which was the first commercial turboprop to enter service. It offered a pressurized cabin and economical all-around performance, making it popular with regional airlines. This example, arriving in Norfolk on July 11, 1955, is inaugurating Capital Airlines service to Chicago via Washington. (NPL.)

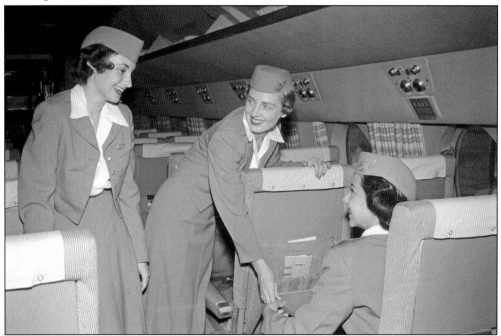

Capital Airlines stewardesses prepare for the press during Capital Airlines promotion of its new Norfolk to Chicago turboprop service aboard Vickers Viscounts. The jet age not only represented the advent of higher-performance aircraft, but also a significant cultural shift as air travel became more affordable and open to the middle class. This in turn created greater markets in areas previously underserved by airlines. (NPL.)

National Airport, seen as it appeared around the end of World War II, prospered through the mid-1950s, but revolutionary long-haul turbojet aircraft, like the Boeing 707 and Douglas DC-8, could not operate from its relatively short runways. The advent of medium-haul turbojets, like the 727, 737 and DC-9, kept National a viable secondary airport for the Washington region, while the longer-haul operations moved to Dulles Airport at Chantilly. (NASM.)

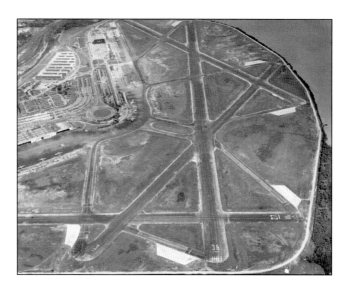

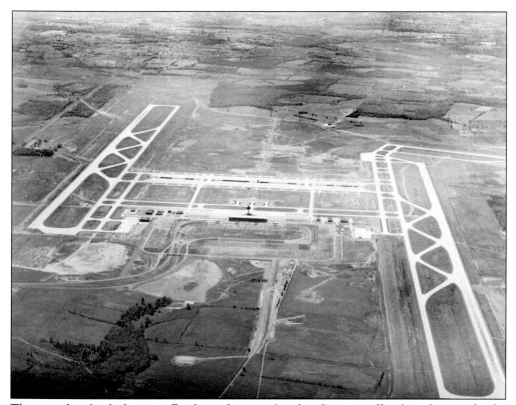

The open farmland of western Fairfax and eastern Loudon Counties offered ample space for the new jet-age terminal of Dulles—one that could even accommodate the supersonic Concorde. Dulles's remoteness from the center of the nation's capital kept National Airport as a popular alternative for shorter domestic flights. As with National Airport in 1941, Dulles, when it opened in 1962, set a new standard for American airport design. (NASM.)

# Discover Thousands of Local History Books Featuring Millions of Vintage Images

Arcadia Publishing, the leading local history publisher in the United States, is committed to making history accessible and meaningful through publishing books that celebrate and preserve the heritage of America's people and places.

Find more books like this at
**www.arcadiapublishing.com**

Search for your hometown history, your old stomping grounds, and even your favorite sports team.

Consistent with our mission to preserve history on a local level, this book was printed in South Carolina on American-made paper and manufactured entirely in the United States. Products carrying the accredited Forest Stewardship Council (FSC) label are printed on 100 percent FSC-certified paper.